W9-ALW-790

In a Patchwork Garden

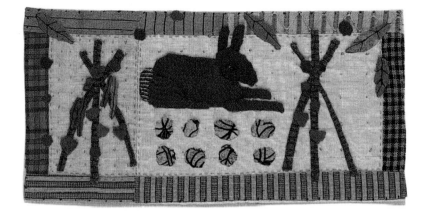

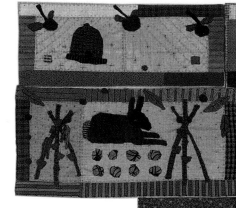
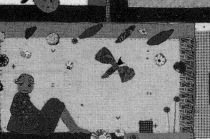
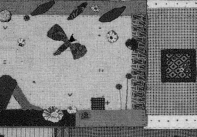
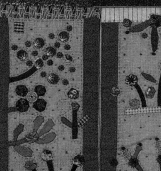
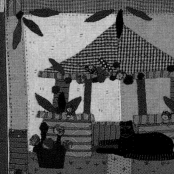
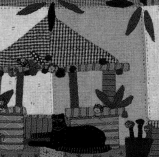

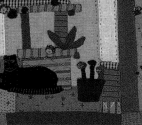
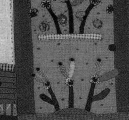
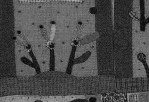

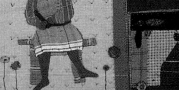

In a Patchwork Garden

GARDEN DESIGNS IN APPLIQUÉ

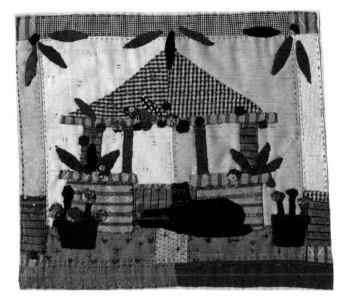

JANET BOLTON

 THE QUILT DIGEST PRESS

Simply the Best from NTC Publishing Group

Lincolnwood, Illinois U.S.A.

Editor: Ljiljana Ortolja-Baird
Designer: Bet Ayer
Printed in Singapore.

Cataloging-in-publication data is available from the Library of Congress.

The author has endeavored to ensure that all project instructions are accurate. However, due to variations in readers' individual skill and materials available, neither the author nor the publisher can accept responsibility for damages or losses resulting from the instructions herein. All instructions should be studied and clearly understood before beginning any project.

Published by The Quilt Digest Press
a division of NTC/Contemporary Publishing Company
4255 West Touhy Avenue
Lincolnwood (Chicago), Illinois 60646-1975, U.S.A.
© 1997 by Museum Quilts Publications, Inc.
Text and illustrations © 1997 by Janet Bolton.
All rights reserved. No part of this book may be reproduced,
stored in a retrieval system, or transmitted in any form or by any means,
electronic, mechanical, photocopying, recording or otherwise, without
the prior permission of NTC/Contemporary Publishing Company.

First publishing in the United Kingdom by
Museum Quilts (UK) Inc.
254-258 Goswell Road
London EC1V 7EB

CONTENTS

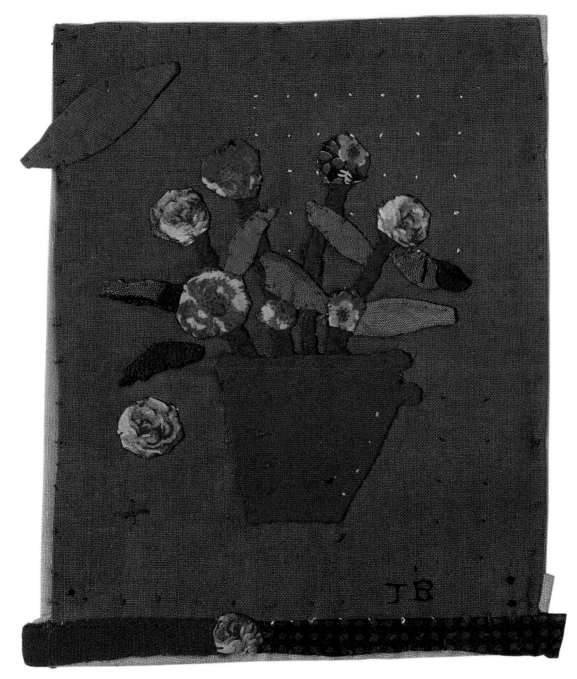

Flowers from my garden

FOREWORD

This book combines two of life's great pleasures–needlework and gardens–in the inspiring words and works of Janet Bolton. Many people are fond of and familiar with her unorthodox stitching skills and impeccable taste. Here she presents herself in a new guise–that of a keen observer and connoisseur of matters horticultural. She writes about plants and creatures as if she knows about them first hand, and manages to capture their essence in the trademark muted colours, the fine checks and spots that her many fans find so satisfying.

Janet Bolton has a classic way with fabrics. Time after time she achieves a faultless partnership of check to plain, sand brown to smoky blue, delicate cotton lawn to textured linen. Her designs have a quietly ordered spontaneity that looks utterly natural, and are the result of much thought and an incomparable eye. Her apparently effortless skill in producing work that always looks right and has an almost childlike simplicity, is deceptive. If you have ever tried to emulate her casual expertise, you will know how difficult it is to achieve just that balance of color, that wit and whimsicality which never strays into sentimentality. Her work is the precise point at which naiveté and sophistication meet.

Which is why this book is such a gift to Janet Bolton fans. Not only can you relish her own particular renditions of butterflies and beasts and borders. But generously, she also shows you how to put the fabrics together, the shapes to cut, the stitches to use, and how to adapt her designs to immortalize your own cabbage patch in long-hoarded scraps. You can pore over the photographs minutely, seeking to extract the elusive secret of her style–the detail is such that you can almost feel the different textures of fabric, and you can see the precise nuances of color. The drawings, too, are fascinating, and suggest variations and further possibilities of color and stitch. One of the great pleasures of this book is that, as with a good cookery book, the real point is your version. You cannot fail to enjoy the book as a record of Janet Bolton's work. If it also gets you cutting and stitching, you may end up with a single picture, or an entire horticultural quilt. And who knows? Some of her extraordinary serenity may come with it.

Miranda Innes

INTRODUCTION

As a thing of beauty, a well-planned garden will inspire creativity, just as great works of art have inspired garden design. Little wonder when the architects of each have such similar aims in mind. Gardeners and painters both manipulate colors, patterns and shapes to bring together a pleasing whole. Each uses his materials to portray a personal vision, evoke atmospheres, create illusions, and to provide a suitable setting in which to display his own particular enthusiasms and eccentricities.

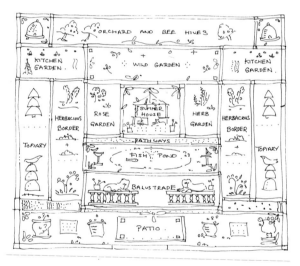

One garden can stimulate so many creative ideas for pictures or gardens. A group of people working from the same inspiration will each interpret it in different ways, each emphasizing the features that pleased him most, exaggerating one quality, playing down another. Every blank canvas or new garden project has its own challenges and frustrations. The makers' skill and vision, the availability of space, materials and time will all determine the finished product.

This garden picture represents a mixture of imaginary, known, and half-remembered gardens. It can be used as a firm plan to follow closely, or as a guideline from which your own preferences can be developed. The finished quilt at its widest point measures

35½ x 40in/90 x 102cm. Many of you will only have time, space or inclination to make a few of the pictures and so I have designed each picture to stand on its own. The final arrangement of pictures can be changed or you may even want to frame each piece individually. After seeing all the finished pieces together I altered the overall layout from a square to a kimono shape.

The creative gardener has to take into account the quality of soil conditions, light, shade, and space available. These conditions may limit or expand the choice of suitable plants. Plants will be selected with an eye to how well they look and group together. In just the same way, when preparing to make a picture the suitability of fabrics needs to be considered. For this type of work, light-weight cottons, silks, wools or syn-thetics are ideal. Thick or heavy fabric is difficult to turn under with ease and usually gives an uneven finish. Just as you would choose an arrangement of flowers and plants to complement each other, choose fabrics you like and place them next to each other to see how they look, rather than trying to match them to the ones used here. I have provided full-size templates for all the picture panels, however do feel free to mix and match elements from different pictures to make up your own designs. You may even have a favorite part of your garden that you want to immortalize in fabric. Take a photograph, enlarge it to the size of the finished piece and trace off the shapes to make templates. You do not have to be a sewing wiz to make a picture. My sewing techniques are simple and unorthodox; a small glossary of stitches and step-by-step instructions for each picture will help you on your way to creating your dream garden.

THE ORCHARD

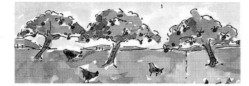

Records of early medieval gardens mention the cultivation of apples, pears, cherries, apricots, mulberries, walnuts and figs.

In most gardens of the past, plants were not grown unless they had some practical function, for food, medicine, perfume or even for magical purposes. Gardens made purely for aesthetic considerations were few and belonged only to the very privileged. Because of this, the frothy pink and white blossoms on fruit trees must have been a welcome and much appreciated sight to the early gardener. Today, even amongst the profusion of plants that we have available, fruit trees or even just one tree alone can have great impact in a garden plan. The blossoms provide floods of early color at a good height. The trunks can be utilized to support climbing plants. All this without the delicious addition of the fruit itself.

I painted the watercolor design below from a photograph shot looking up into a tree. As pointed out by the photographer it is reminiscent of a William Morris wallpaper.

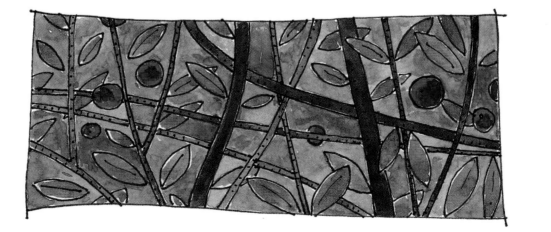

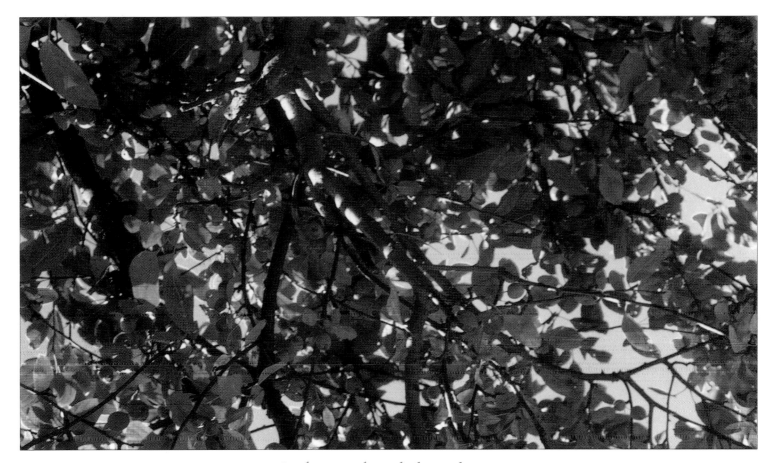

Looking up through the apple tree

The simplified watercolor gave me the idea for a perfect top border for my quilt. The shapes of the tree canopy are not too intricate and will lead the eye down the quilt. To form a visual "stop" at each cor-ner I placed beehives.

They are simple rounded shapes and provide a wonderful addition to any orchard. Bees could have taken the place of the butterflies, but the repetition of the but-terfly motif elsewhere is a useful device to both integrate the different elements as well as to direct the eye along the different panels.

11

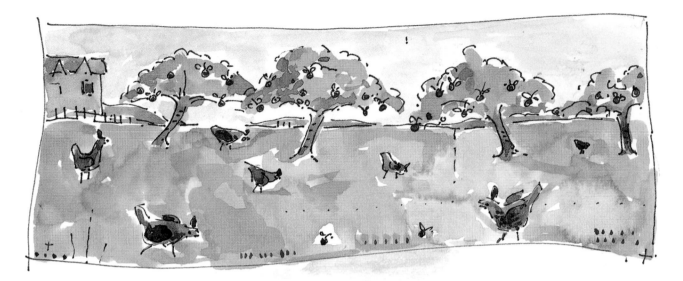

As a child I remember free range hens in farm orchards and being sent to look for the eggs of hens "laying away". Today driving along the winding lanes of Kent, England, flanked by old orchards, is a pleasure. I love to see sheep standing in the shade of old soft fruit trees. Both these memories are waiting to be translated into pictures.

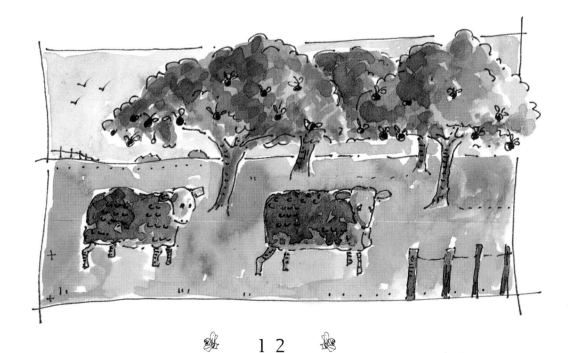

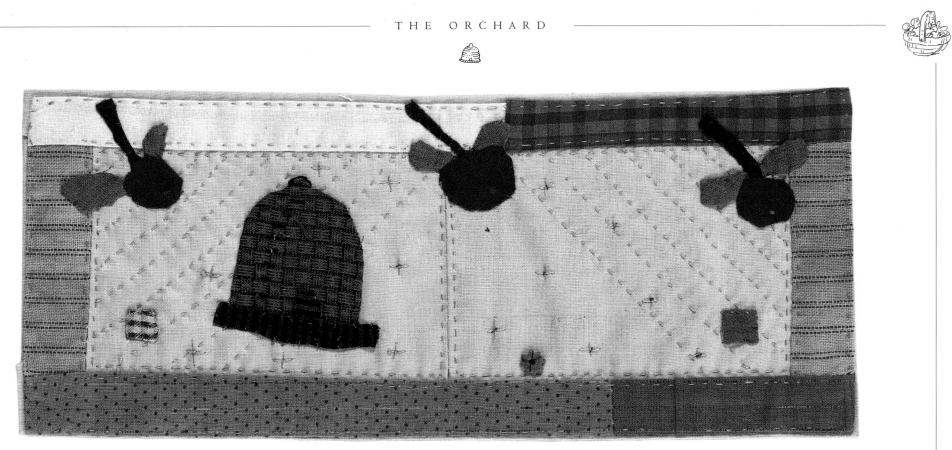

Above: *Beehive Under Three Apple Trees* Below: *Beehive and Wild Cherries*

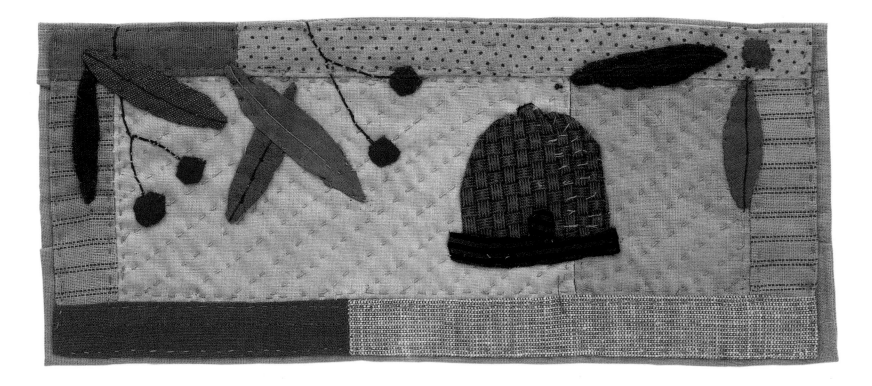

Above: *Cherry Trees*

Left: *Blue Butterfly*

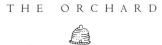

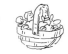

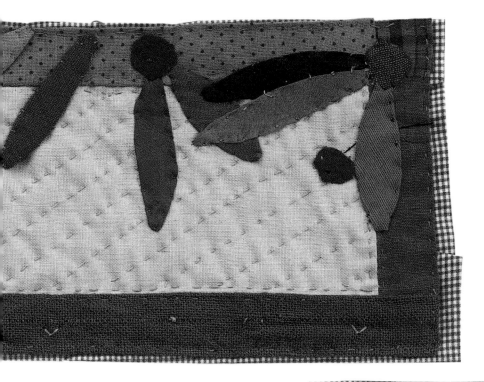

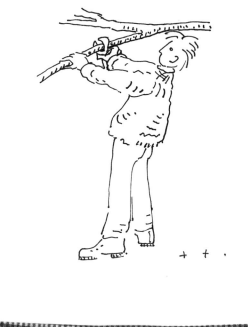

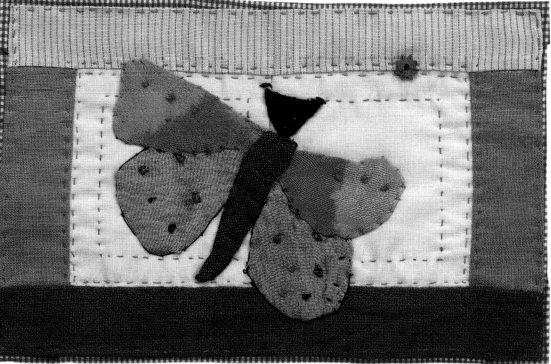

Right: *Yellow Butterfly*

MAKING THE ORCHARD

The orchard runs along the top of the quilt and is made up of five separate pictures. A full-size template is provided for each piece. I have written instructions for *Beehive and Wild Cherries* (right-hand corner piece) only, but since the method of assembly for each picture is exactly the same, you can follow this set of instructions.

Each picture for the orchard was made with deliberate simplicity to complement the rest of the quilt. However I did want each picture to be pleasing in its own right

and so I added extra textural interest to each background. The *Butterfly* pictures have a double line of running stitches around the perimeter of the blue background. On *Cherry Trees* I used parallel lines of running stitches diagonally across the picture. For *Beehive Under Three Apple Trees*, I chose a pattern of converging parallel lines of running stitches. When completed, I added crosses stitched in yellow and secured with contrasting colored floss.

MATERIALS

Use the templates as a guide for fabric quantities, remembering to add $1/4$ in/0.6 cm turning-under allowance to all shapes and $1/2$ in/1.3 cm allowance for the backing.

- Plain cotton or curtain lining for the backing for the two Beehive pictures
- Brick red and white check for the backing for *Cherry Trees* and the *Butterfly* pictures
- Plain cotton or curtain lining for the background; for the *Beehive and Wild Cherries* picture you will need two contrasting neutral-colored pieces
- Fabric strips suitable for the borders

- Selection of fabric scraps for the appliqué shapes
- Beads for *Cherry Trees* and *Butterfly* pictures
- Sewing cotton, needles, pins, scissors, tracing paper

MAKING UP
Beehive and Wild Cherries
1. Trace the template twice onto tracing paper. Then make paper templates for all the shapes including the background and border strips.

2. Cut the backing piece adding $1/2$ in/1.3cm turning-under allowance to each edge.

3. Cut the border strips adding $1/4$ in/0.6cm turning-under allowance around all the edges, then cut the two background pieces.

4. Following the diagram below, sew the two background pieces together using $1/4$ in/0.6cm seam allowance.

5. Sew the two striped borders to either side of the background using $1/4$ in/0.6cm seam allowance.

6. Sew together the top and bottom borders using $1/4$ in/0.6cm seam allowance.

7. Sew the top and bottom borders to the background using $1/4$ in/0.6cm seam allowance.

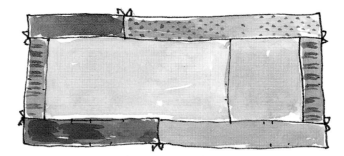

8. Center the assembled background on the backing, wrong sides together.

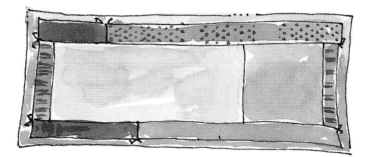

9. Following the diagram below, turn under the edges of the background and turn in the edges of the backing to be just visible. Pin all the layers together, then sew through all the layers using a simple running stitch.

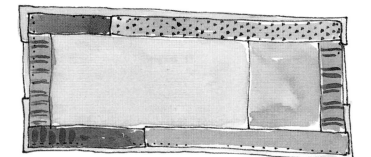

10. Using your templates or cut freehand, the hive, cherries and leaves, adding by eye a ¹/₄ in/0.6cm turning-under allowance.

11. Pin the shapes in place and appliqué using the needle-turning method. Where

motifs are built up of more than one fabric shape or where motifs overlap, always place and secure the underneath shapes first.

12. Make the cherry stems by couching lines of black sewing thread to the background. Secure the lines with neutral colored thread. Use a French knot to indicate the small indent at the base of the fruit.

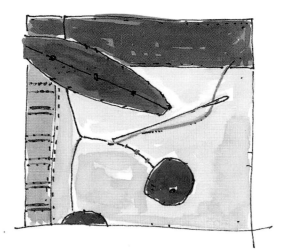

13. Use a small running stitch to quilt the parallel diagonal lines across the background.

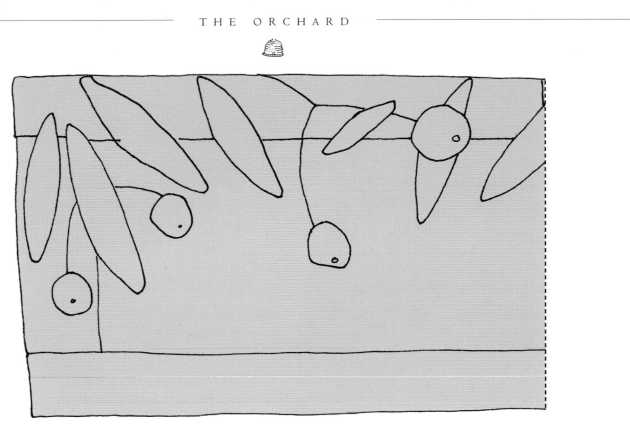

Cherry Trees template (left half)

Cherry Trees template (right half)

Blue Butterfly template

Yellow Butterfly template

Beehive Under Three Apple Trees template

Beehive and Wild Cherries template

THE WILD GARDEN

The destruction of hedgerows and the use of pesticides have combined to destroy many species of wild flowers and grasses, so it is a real delight to leave a space in the garden where their growth can be encouraged. Not that a designated "wild" patch can be left to look after itself completely if less vigorous varieties of flowers are to be encouraged. In my wild garden, the brambles are allowed to grow against one fence only and have to be cut back to prevent them from claiming the whole area. A particularly large species of buttercup would also happily take over, leaving no room for the small variety that I love. Fortunately they are very easy to pull out, unlike some plants. And the rampant thistles, I have to catch before the seeds disperse or my neighbors would not be too pleased.

This process of taking things out to create a simple, pleasing area applies to both gardens and pictures. The ruthlessness required is easy to summon up in a wild garden, much more difficult in an area of carefully cultivated plants. In gardening as in picture making, the temptation is to put too many ideas into one area, not allowing for growth or for the space required between shapes. Fortunately in both cases the unwanted ideas can be transplanted and allowed to bloom in a different situation.

The watercolor in this chapter is of a very busy person with a garden much too large to maintain alone. The owner, who is a great animal lover, found a simple solution to her problem. Two goats crop the area. The garden is in the Yorkshire Dales, England, surrounded by a beautiful dry stone wall.

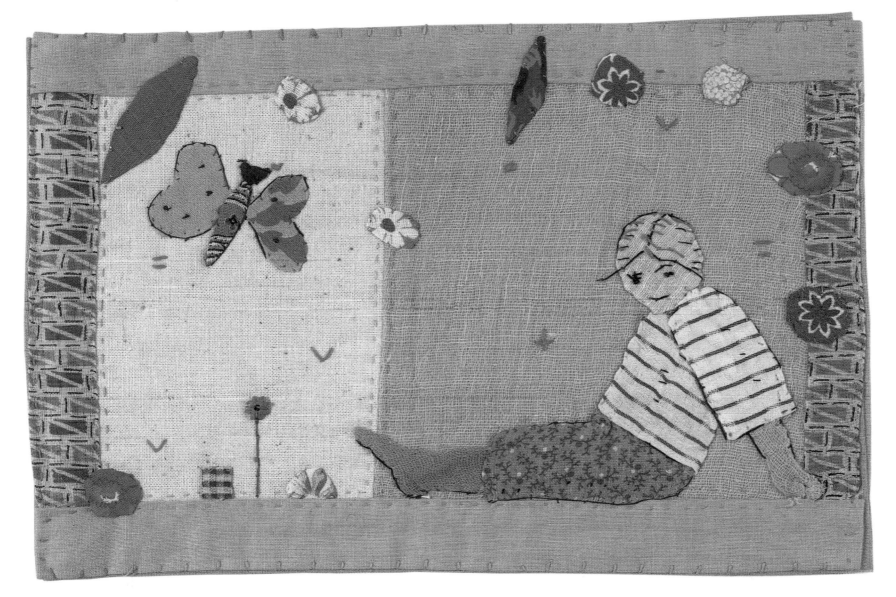

Daphne in the Wild Garden

Flora in the Wild Garden

The uncultivated area now blends beautifully with the surrounding countryside. Plants are grown in pots next to the house on the other side of a stout picket fence and the gate is kept securely locked. The only plants these goats don't eat–they will eat the washing or your clothes if you stand idle too long–are dandelions, and they always leave nettles until last. This is a garden in which the normal proportions of wild to cultivated are reversed but it is very successful. The beauty of the area is allowed to speak for itself.

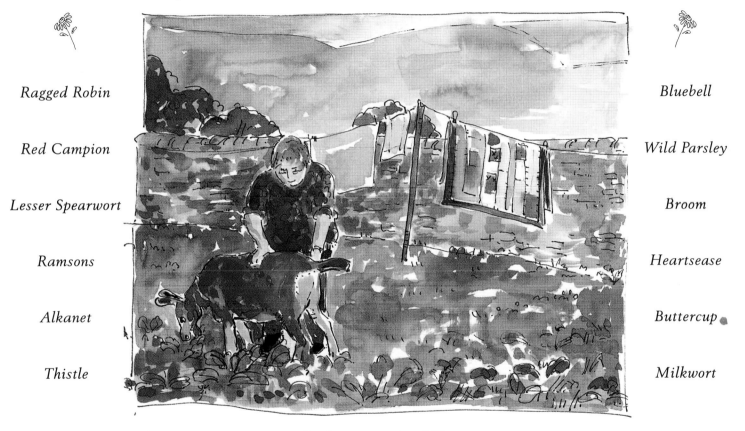

Ragged Robin

Red Campion

Lesser Spearwort

Ramsons

Alkanet

Thistle

Bluebell

Wild Parsley

Broom

Heartsease

Buttercup

Milkwort

Ruth encouraging Billy

The wild garden, unless you have been fortunate enough to cultivate some very rare species, is a perfect area in which children can play. My original idea for the quilt was to have seated children making daisy chains, but a calm, restful attitude fulfilled the design requirements of balance, so for the moment the daisies are left unpicked.

Flora and Daphne in the Wild Garden

MAKING THE WILD GARDEN

MATERIALS

Use the templates as a guide for fabric quantities, remembering to add ¼ in/0.6cm turning-under allowance to all shapes and ½ in/1.3cm allowance for the backing.

- Plain cotton or curtain lining for backing
- Plain cotton or curtain lining for background, use two contrasting beige colors for *Daphne in the Wild Garden*
- Fabric strips suitable for borders
- Selection of fabric scraps for the children, butterflies, flowers and leaves
- Sewing cotton, embroidery floss, needles, pins, scissors, tracing paper

MAKING UP

Flora in the Wild Garden

1. Trace the template twice onto tracing paper. Make paper templates of all the shapes including the background and border strips.

2. Cut the backing piece adding ½ in/1.3cm turning-under allowance to each edge.

3. Cut the border strips adding ¼ in/0.6cm turning-under allowance around all the edges, then cut the background.

4. Following the diagrams below, sew the background and border pieces together using ¼ in/0.6cm seam allowance.

5. Center the assembled background on the backing, wrong sides together.

6. Following the diagram below, turn under the edges of the background and turn in the edges of the backing to be just visible. Pin all the layers together, then sew using a simple, long running stitch to give a distinct pattern of "dots" around the outside edge.

back *front*

7. Use your templates or cut freehand all the appliqué motifs, adding by eye a 1/4 in/0.6cm turning-under allowance around each shape.

8. Pin *Flora* in position, work upwards starting from the leg, then the shorts, midriff, arm, sleeve and finally the head.

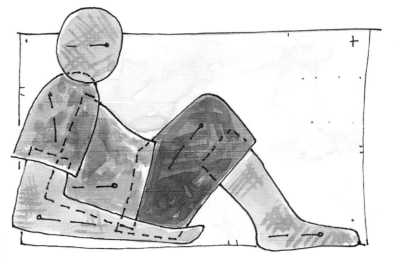

9. Appliqué using the needle-turning technique. Using the photograph as a guide, position and pin, then sew the butterfly, flowers and leaves in place.

10. Add the final top stitching for emphasis and added texture, using the photograph as your guide. I used a couched line for *Flora's* nose, mouth and hair and the flower stalks, and for her eyes, a cluster of small stitches.

11. To give a summer sparkle to your picture, work some random stitch shapes on the background using two strands of yellow embroidery floss.

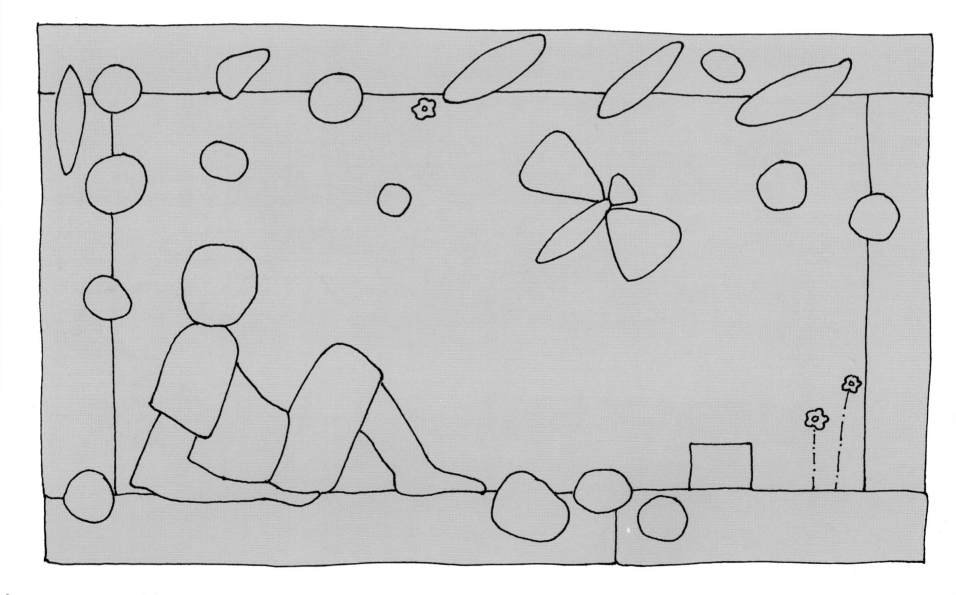

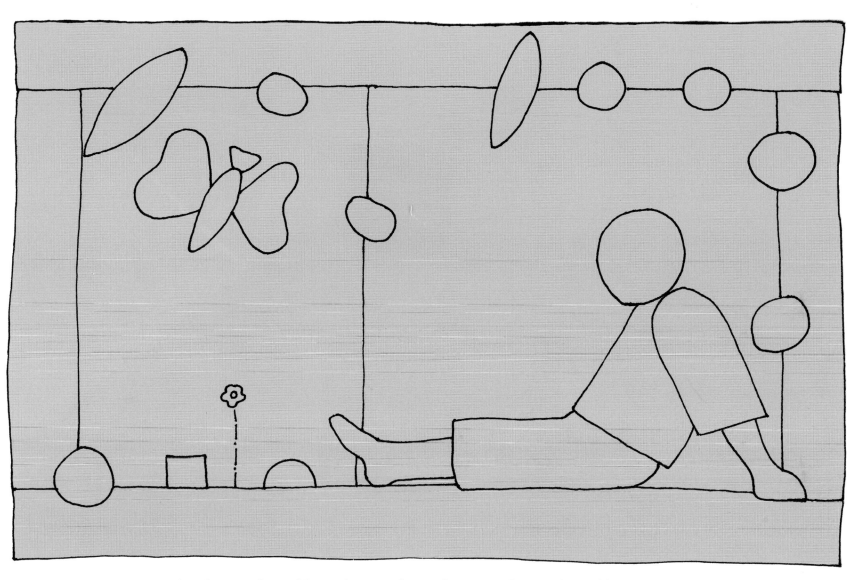

Left: Flora in the Wild Garden template Above: Daphne in the Wild Garden template

Daphne in the Wild Garden
To make *Daphne in the Wild Garden* follow the directions for *Flora in the Wild Garden*. Remember to sew together the two background pieces before adding the border strips. To add definition to the butterfly I used a couched line. This was also a useful device to indicate the stem of the flower.

THE KITCHEN GARDEN

Kitchen gardens have a beauty of their own. Like a piece of good engineering, the design evolves from functional considerations, and in the development becomes aesthetically pleasing. In many gardens, particularly where space is at a premium, vegetables and flowers are intermingled to the benefit of both and to the overall appearance. Planning a kitchen garden is very different from planning any other area of your garden. Crops are

rotated to avoid garden pests and to enrich the soil, so there can be no long term visual plan. And since almost all vegetables are planted seasonally there is no waiting for plants to mature over many years. In the fall the plots are cleared and lie patiently

for next season's crops. There is no need to worry about planting too closely, or obscuring views, or creating too much shade. It is the orderly rows, the pathways for access, and the various supports made for the vegetables to grow up that create the visual structure of a kitchen garden. The pattern of the various size and shape plots become as pleasing a part of the garden as any other. In high summer, the softened geometry of a lush green vegetable plot forms a satisfying contrast to the rigid formality of clipped topiary and a complete and dramatic change from

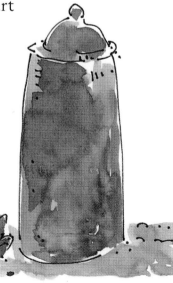

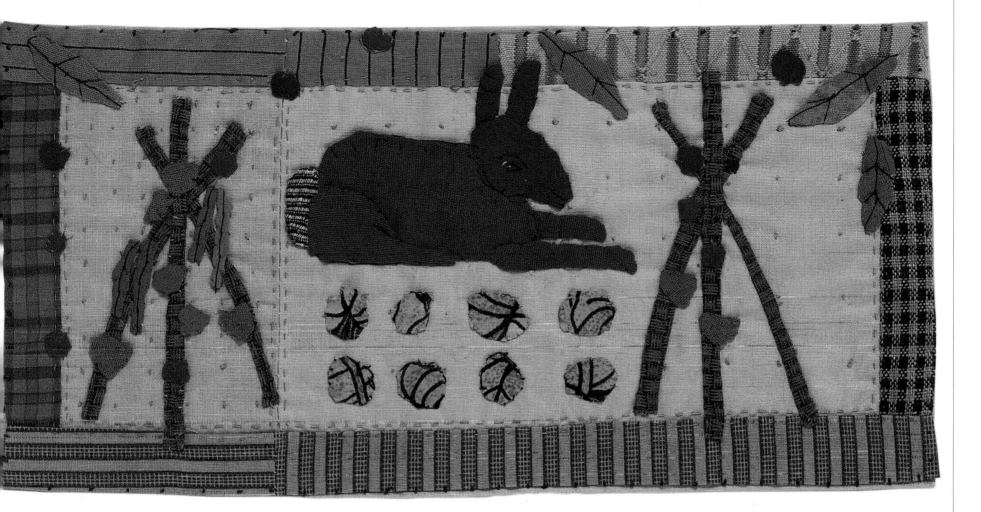

Rabbit Amongst the Young Cabbages

the bold sweeps and curves of color which are found in abundance in the herbaceous borders.

Early monastery gardens and kitchen gardens of grand houses were usually sheltered behind beautifully wrought brick walls. These large kitchen gardens were tended by several gardeners who with their considerable expertise produced a staggering variety of crops, capable of feeding

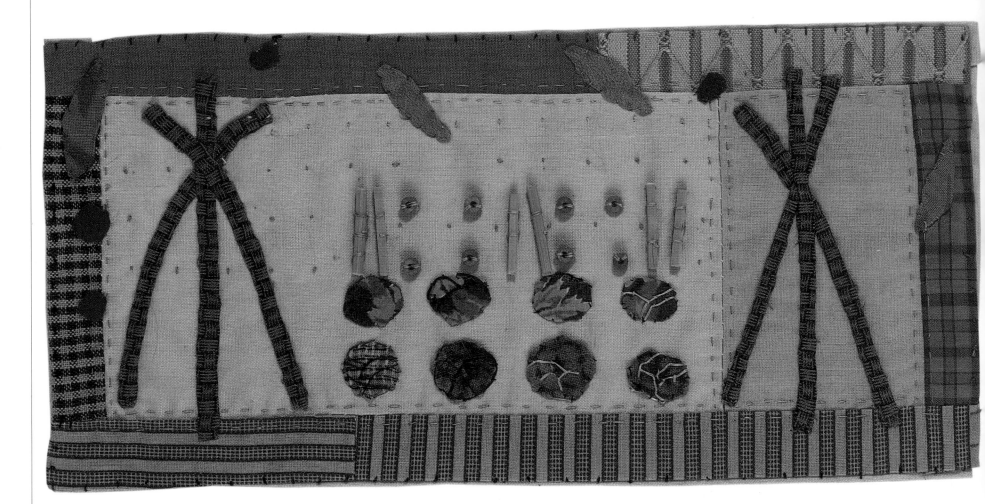

Mature Cabbage Patch

large households and with sufficient surplus to send to city relatives. In contrast, today suburban and cottage gardens usually have a small self-contained area set aside for vegetables. This is what I have envisaged for my quilt, a modest and manageable garden plot tucked down at the far end of the garden offering a "sweet" sanctuary for the rabbits and birds and an occasional lettuce for myself.

34

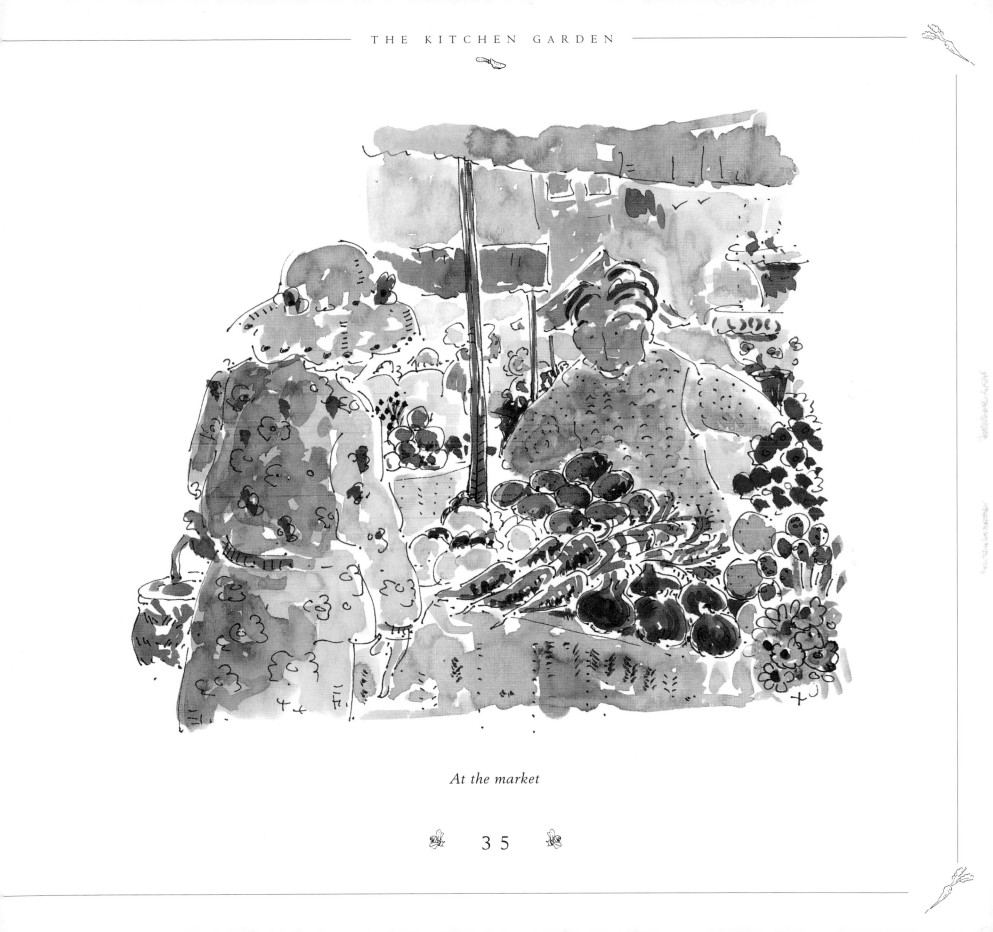

At the market

MAKING THE KITCHEN GARDEN

MATERIALS

Use the templates as a guide for fabric quantities, remembering to add $1/4$ in/0.6cm turning-under allowance to all shapes and $1/2$ in/ 1.3cm allowance for the backing.

- Plain cotton or curtain lining for the backing
- Two contrasting neutral-colored cotton fabrics for the background
- Fabric strips suitable for borders
- Selection of fabric scraps for the rabbit, beans, flowers, bean poles, cabbages and leaves
- Eight wooden beads for the *Mature Cabbage Patch* picture
- Six cane sticks or matches for leeks
- Sewing cotton, needles, pins, scissors

MAKING UP

Rabbit Amongst the Young Cabbages

1. Trace the template twice onto tracing paper. Make paper templates of all the shapes including the background and border strips.

2. Cut the backing piece adding $1/2$ in/1.3cm turning-under allowance to each edge.

3. Cut the border strips adding $1/4$ in/0.6cm turning-under allowance around all the edges, then cut the two background pieces.

4. Machine or hand sew together the two background pieces using $1/4$ in/0.6cm seam allowance.

5. Following the diagrams below, sew the background and border pieces together using $1/4$ in/0.6cm seam allowance.

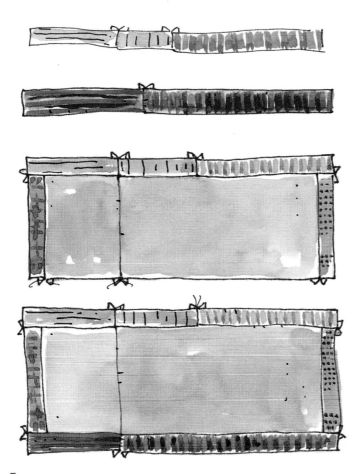

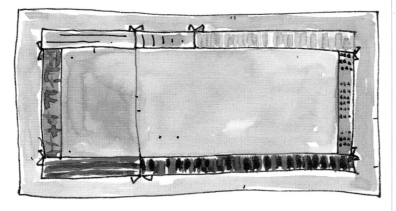

6. Center the assembled background on the backing, wrong sides together.

7. Following the diagram below, turn under the edges of the background and turn in the edges of the backing to be just visible. Pin all the layers together, then sew through all the layers using a simple, long running stitch to give a distinct pattern of "dots" around the outside edge.

8. Use your templates or cut freehand, all the appliqué motifs, adding by eye a 1/4 in/0.6cm turning-under allowance all around each shape.

9. Pin the rabbit in position on the background and secure using the needle-turning technique.

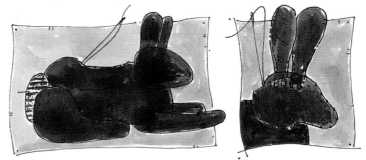

10. Pin, then sew the bean poles and cabbages in place.

11. Position all the beans, leaves and flowers using the photograph as a guide. When you are happy with the arrangement, pin, then appliqué in place using the needle-turning technique.

12. Using the photographs as a guide, add the final top stitching for emphasis and added texture. A simple couched line over some of the cabbages is probably sufficient to indicate the texture of the leaves.

Rabbit Amongst the Young Cabbages template

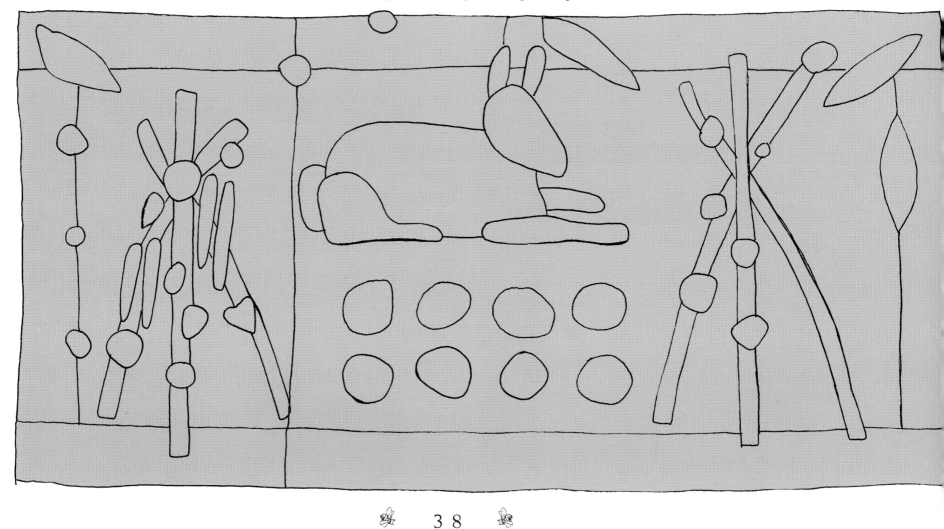

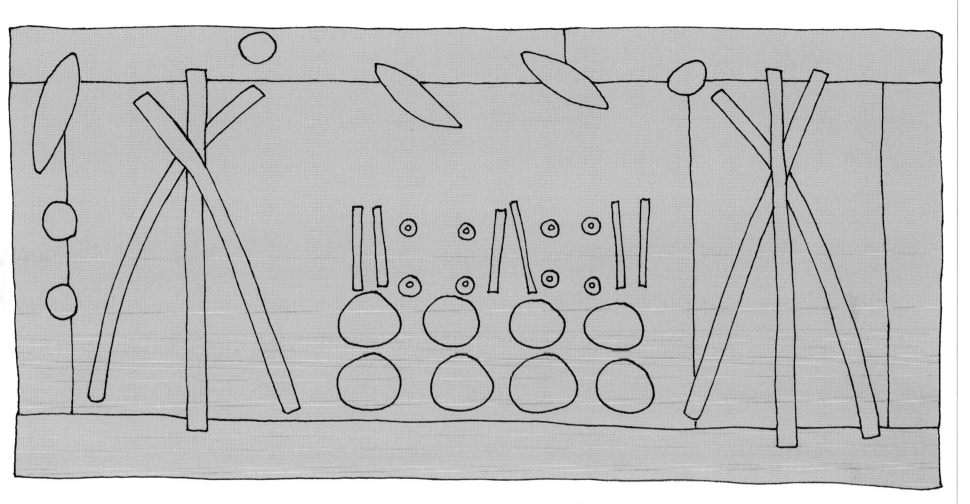

Mature Cabbage Patch template

Mature Cabbage Patch

To make the *Mature Cabbage Patch* follow the directions set out for *Rabbit Amongst the Young Cabbages*. To represent the leeks, I used short lengths of basket cane and broken match sticks. For the small turnip heads, I used small wooden beads. Secure the leeks to the fabric using a thimble and strong needle, and sew through the cane and wood lengths into the material below.

HERBACEOUS BORDERS

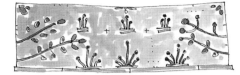

The paintings of the French Impressionists come to mind when I look at a well-established herbaceous border. A bank of multi-colored annuals in bloom with all the variation of shades has the same painterly quality of a late Monet painting. Infact Monet created a magnificent garden at Giverny which later inspired his floral masterpieces.

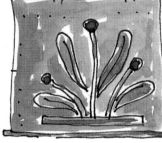

English painter Gertrude Jekyll, when her eyesight deteriorated, channeled her creative spirit into gardening. She approached her new medium with the same principles and theories that she had applied to painting. Her garden designs make full use of generous sweeps of color and shape. In her books on gardening she advises gardeners to guard against rigidly adhering to one set idea or theme. She suggests looking beyond the original idea and "seeing" the creation you are making by keeping your mind open to variations in direction.

The watercolor sketch here depicts a herbaceous border in its full glory. A profusion of colors, some merging into one another, some vibrant against a contrasting background. To enjoy such gardens you don't need to know the name of each flower, and in making a picture there is no need to conform too closely to botanical accuracy. Without the limitation of depicting actual plants choose a multi-colored selection of

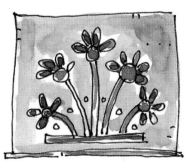

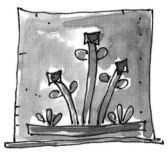

Opposite Left: *The Walled Walkway* Opposite Right: *The Broad Bed*

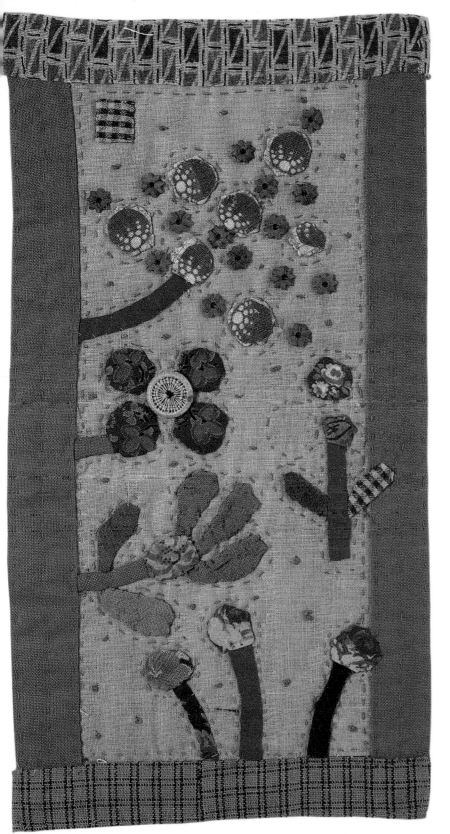

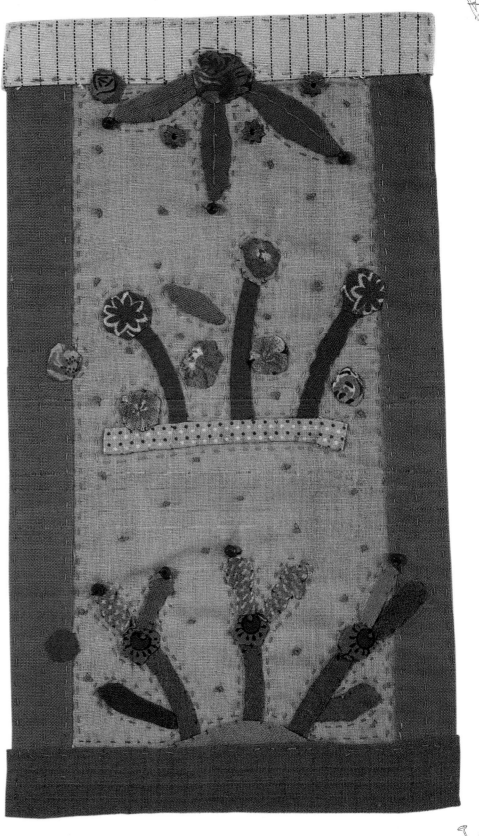

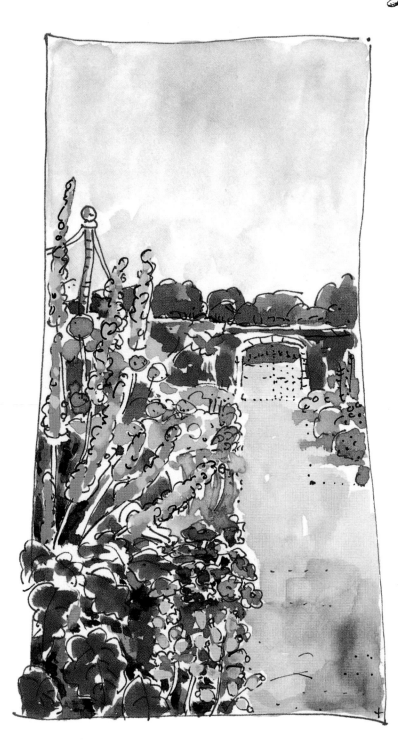

fabrics that look well together and plan your border with those. Use some of the fabrics in different parts of the quilt to link the whole design. Choosing harmonious colors can be difficult. To find the contrasting colors to your main colors, draw two small squares, 1in/2.5cm each and about 4in/10cm apart on a sheet of white paper. Color one in, gaze steadily at the color for a minute, then transfer your gaze to the empty square. As if by magic, the contrasting and complementary color will appear in the empty square, a spot of which will add sparkle to your picture.

The four borders on either side of *The Summer House* are designed to be almost identical, but not quite. They have the same structure, elements and colors, but true to life, none of the plants quite grow to formula.

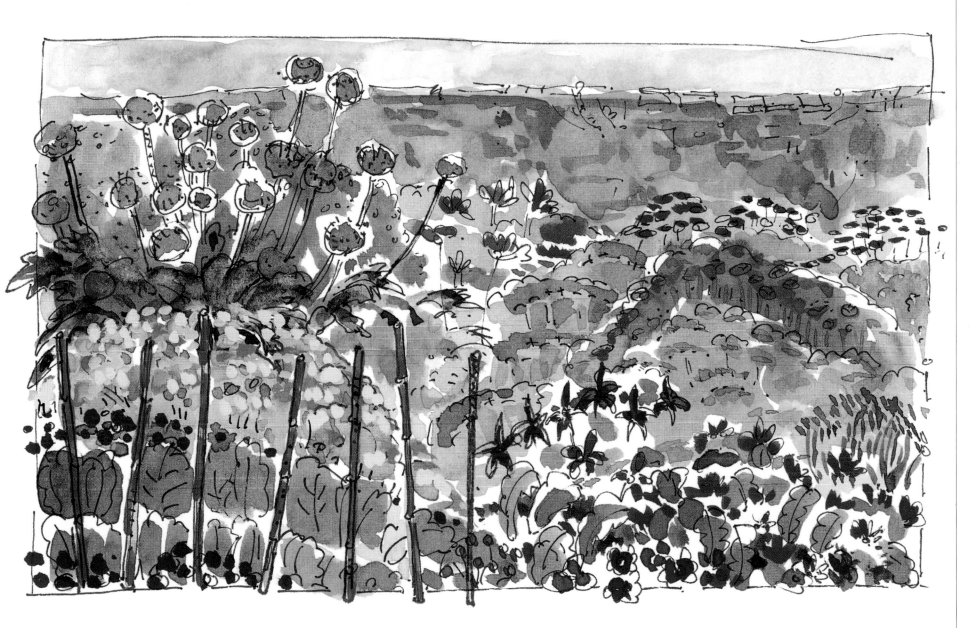

In full bloom

MAKING THE HERBACEOUS BORDER

Although each border is slightly different in design, each can be assembled in the same way following the instructions below.

MATERIALS

Use the templates as a guide for fabric quantities, remembering to add ¼ in/0.6cm turning-under allowance to all shapes and ½ in/1.3cm allowance for the backing.

- Plain cotton or curtain lining for the backing
- Plain cotton or curtain lining for the background
- Fabric strips suitable for the borders
- Selection of fabric scraps for the flowers and leaves
- Selection of buttons and beads
- Sewing thread, needles, pins, scissors, tracing paper

MAKING UP

1. Trace the template twice onto tracing paper. Make paper templates of all the shapes including the background and border strips.

2. Cut the backing piece adding ½ in/1.3cm turning-under allowance.

3. Cut the border strips adding ¼ in/0.6cm turning-under allowance around all the edges, then cut the background.

4. Following the diagrams below sew the background and border pieces together using ¼ in/0.6cm seam allowance.

5. Center the background on the backing, with wrong sides together.

6. Following the diagram below, turn under the edges of the background and turn in the edges of the backing to be just visible. Pin together, then sew through all the layers using a simple, long running stitch to give a pattern of "dots" around the outside edge.

7. Use your templates or cut freehand, all the flower and leaf motifs, adding by eye a 1/8–1/4 in/0.3–0.6cm turning-under allowance around each shape.

8. Position all the leaves and flowers using the photograph as a guide. When you are happy with the arrangement, pin in place.

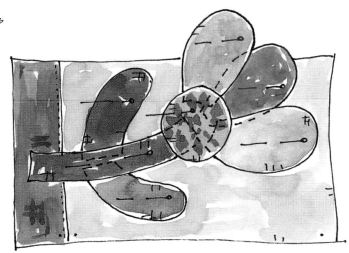

9. Appliqué all the shapes to the background using the needle-turning technique.

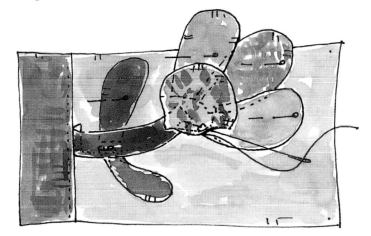

10. Add any beads and buttons. The flowers with four petals have a button center. If you don't have a button, substitute with a small circle of fabric.

11. Using the photographs as a guide only, add the final top stitching for emphasis and texture–use a variety of stitches.

The Walled
Walkway
template

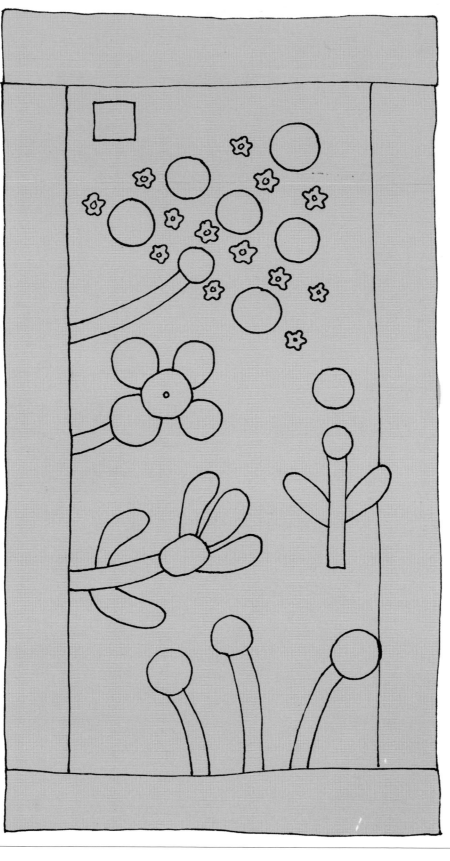

The Broad Bed
template

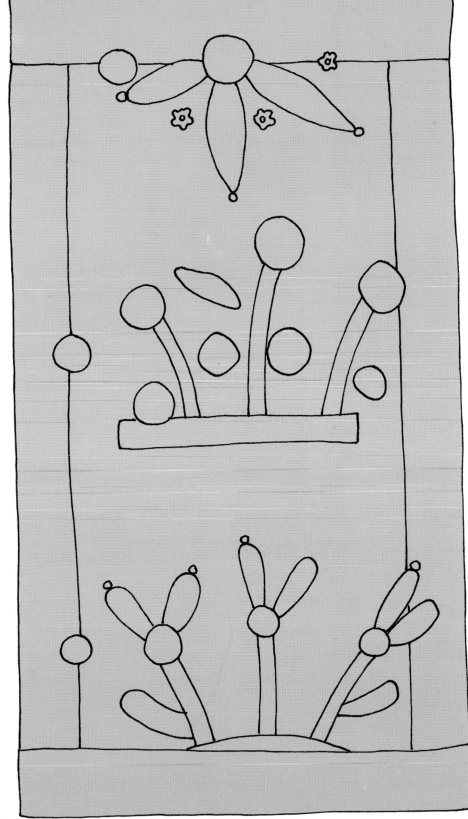

THE SUMMER HOUSE

A summer house is often an excuse for a flight of fancy; a fantastic structure hidden in a far away corner in the grounds of a grand house. Some are elaborate structures, often intricately decorated with pebbles, shells, mirrors and mosaic tiles, others are built as incantations of a simple rustic way of life.

In more modest circumstances, a summer house is frequently built from all sorts of collected materials, and offers a way in which an inventive person can satisfy the longing for self-sufficiency. It's a refuge from the sun, the wind and the rain, a place to dream and take tea, and a place in which to store tools and garden furniture in the winter months.

As a child, my friends and I spent many happy hours building tree houses. After carefully selecting suitable trees at the back of the garden, as far away as possible from interfering grown-ups, we wove walls with branches and foliage. We furnished our "secret" houses with cardboard boxes, old cushions, hardware cast-offs, infact anything we could lay our hands on.

Today my summer house-cum-workroom, rather than being hidden away takes pride of place in a central part of the garden. Similarly *The Summer House* panel in the quilt also has a prime position and is the picture around which all the other elements of the design were built.

Opposite: *Cat by the Summer House*

48

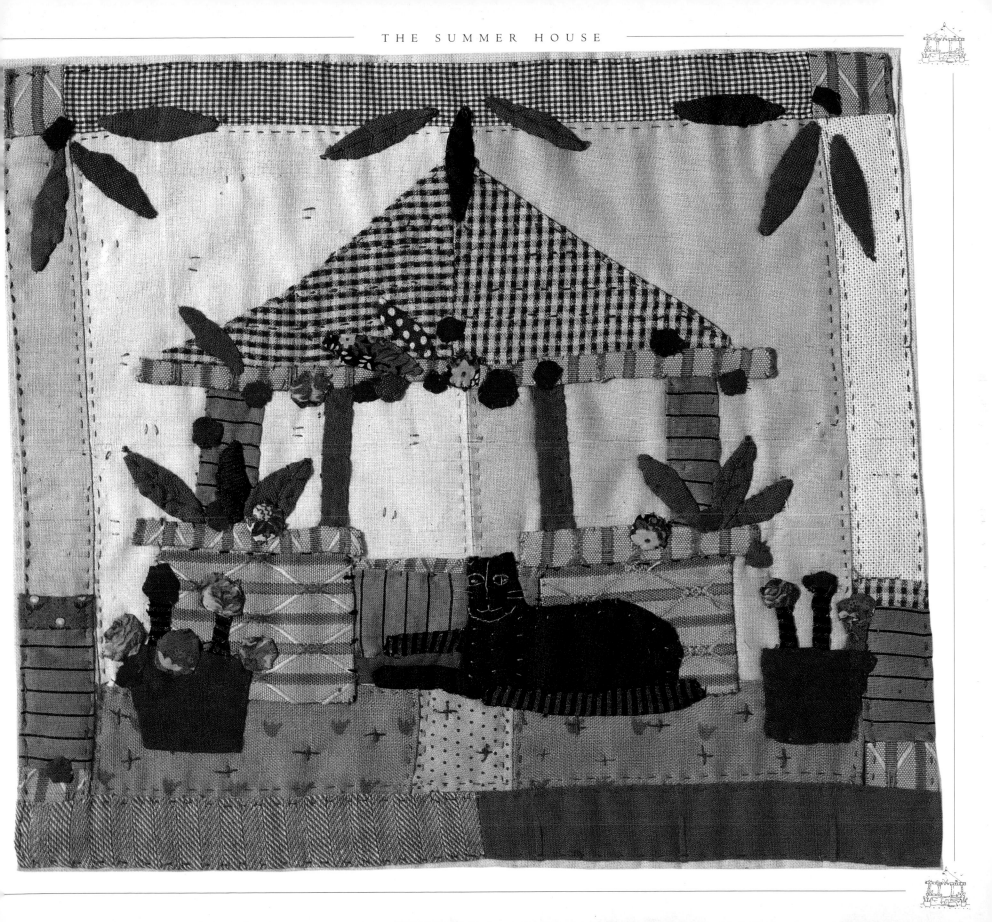

A place to dream ...

At the base of the quilt I have placed a second view of the summer house–a picture inspired by nostalgic memories of lazy days, of ladies in flowery dresses sipping tea out of china cups at garden fêtes and church bazaars. As a child living in a small village the social calendar was linked to the church and the school. Parties in the vicarage garden were an annual occurrence. The inclusion of a figure provides a narrative that I continue throughout the quilt. Two children appear in *The Wild Garden* and two more are placed close by *The Summer House*. The positioning

of the two figures beneath the summer house, one in a tree house and the other sitting reading on a stone bench on the lawn adds to the narrative and helps balance the overall design. Each figure has been depicted in an upright position to provide a perpendicular visual stop to the horizontal lines of the rose garden. In a real garden, an ornament or an imposing plant could take their place. These figurative panels offer an opportunity to personalize the quilt with portraits of your family and pets. The cat could be replaced with a dog, and the children in the wild garden and the tree house could easily assume recognizable features or clothing of your own children or friends.

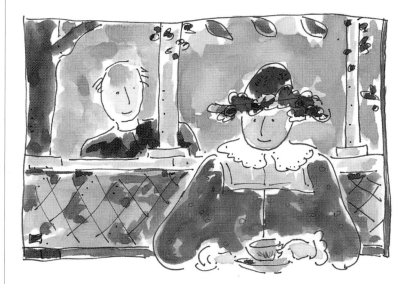

... and take tea

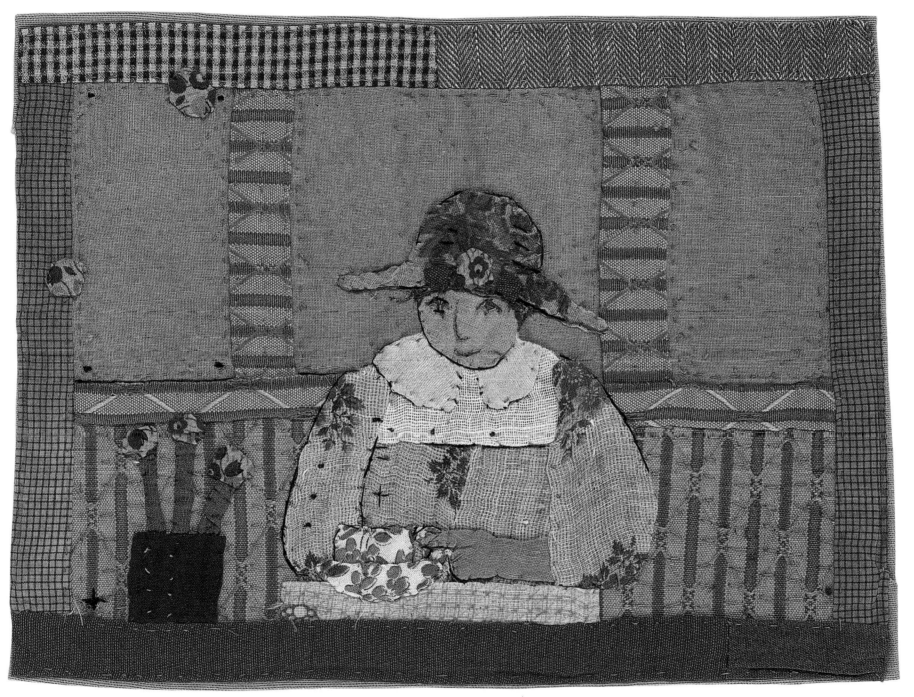

Arcadia Taking Tea

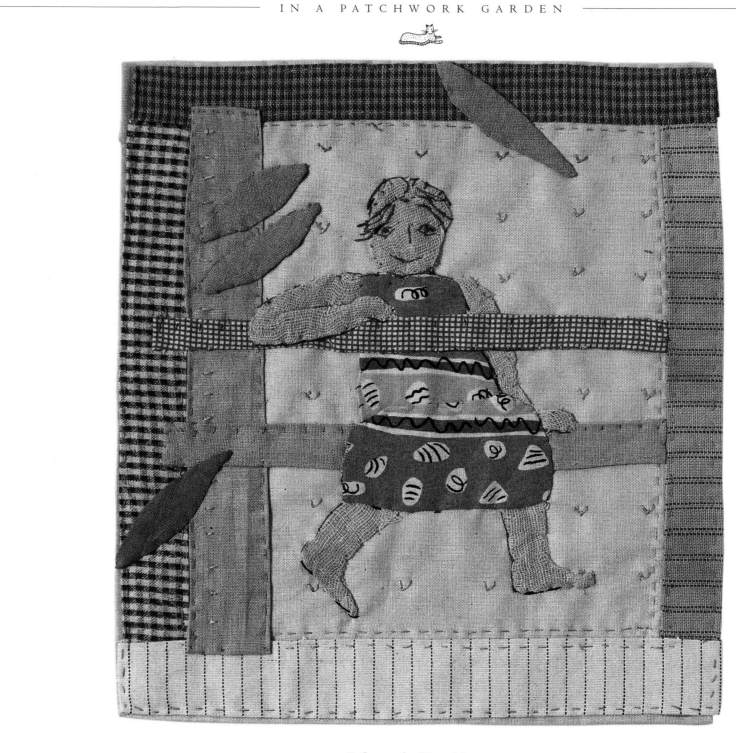

Lily in the Tree House

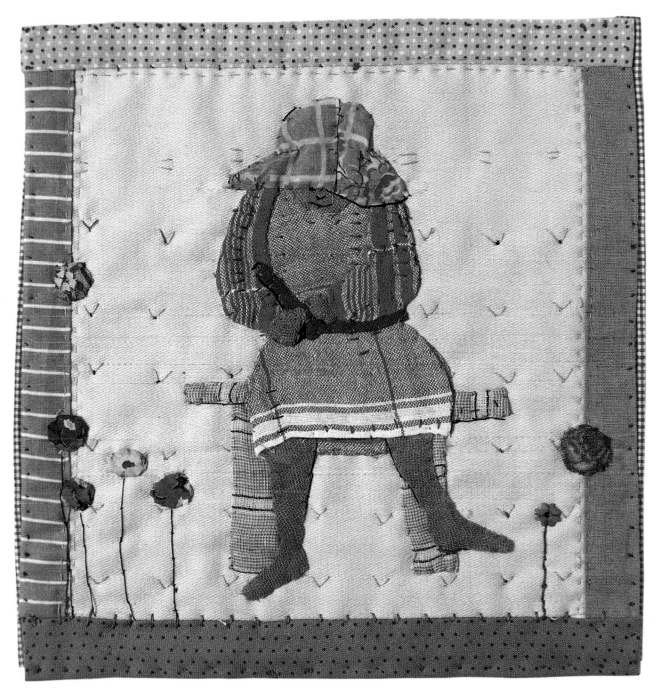

Iris Reading by the Summer House

 5 3

MAKING THE SUMMER HOUSE

Cat by the Summer House

Arcadia Taking Tea

Lily in the Tree House

Iris Reading by the Summer House

MATERIALS

Use the templates as a guide for fabric quantities, remembering to add $^{1}/_{4}$ in/0.6cm turning-under allowance to all shapes and $^{1}/_{2}$ in/1.3cm allowance for the backing.

- Plain cotton or curtain lining for the backing
- Two contrasting neutral-colored fabrics for the background of *Cat by the Summer House*, the other three panels use only one background fabric

- Fabric strips suitable for borders
- Selection of fabric scraps for all the appliqué motifs
- Sewing cotton, needles, pins, scissors, tracing paper

MAKING UP
Cat by the Summer House

1. Trace the template twice onto tracing paper. Make paper templates of all the shapes including the background and border strips.

2. Cut the backing piece adding $^{1}/_{2}$ in/1.3cm turning-under allowance on each edge.

3. Cut the border strips adding $^{1}/_{4}$ in/0.6cm turning-under allowance around all the edges. Cut the two background pieces, the path and the two ground pieces adding $^{1}/_{4}$ in/0.6cm turning-under allowance around all the edges.

4. Following the diagrams opposite, sew together each of the five pieces that make up the background fabric using $^{1}/_{4}$ in/0.6cm seam allowance.

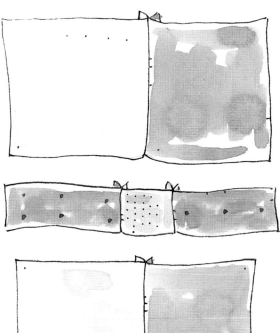

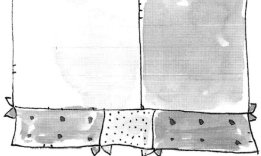

5. Sew the top border to the background using $^1/_4$ in/0.6cm seam allowance.

6. Piece together the three remaining borders using $^1/_4$ in/0.6cm seam allowance.

7. Sew the two side borders to the background using $^1/_4$ in/0.6cm seam allowance.

8. Sew the bottom border to the background using $^1/_4$ in/ 0.6cm seam allowance.

9. Center the assembled background on the backing, wrong sides together.

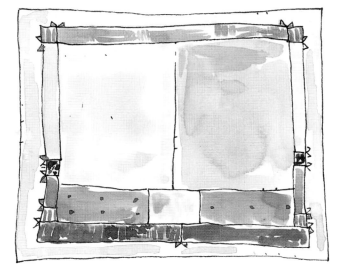

10. Following the diagram below, turn under the edges of the background and turn in the edges of the backing to be just visible.

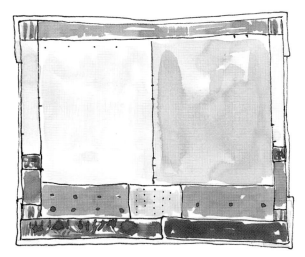

Pin all the layers together, then sew using a simple, running stitch.

11. Use your templates or cut freehand all the appliqué motifs, adding by eye a $1/4$ in/ 0.6cm turning-under allowance around each shape. To get the change of weave direction in the roof I cut it as one piece, then cut it in half. I flipped one half and stitched the two pieces together again.

12. Using your template as a guide, position all the house components on the background. Study the photograph for placement and to work out which parts overlap. I started by positioning the two striped house sides, tucking the door and four pillars underneath. The two ledges were

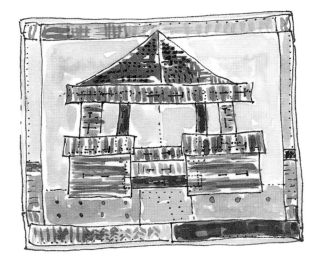

placed on top of the sides and pillars, covering the raw edge of the house sides. I positioned the roof, then the guttering. When you are satisfied with your arrangement, pin the shapes in place.

13. Appliqué the house to the background using the needle-turning technique. Remember not to turn under any edges that will be concealed by another shape.

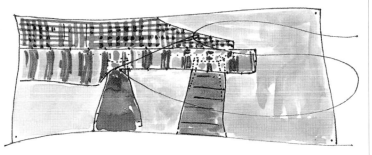

14. Pin the cat in place. The body overlaps one front leg, and the tail overlaps the body and the other front leg. Appliqué to secure.

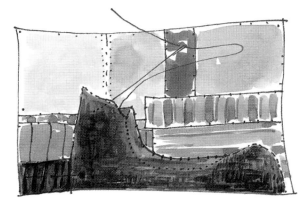

15. Pin the pots in place, and tuck the flower stalks under the rim of the pot. Appliqué using the needle-turning method.

16. Using the photograph as a guide, pin, then sew the flowers and leaves in place.

17. Add the final top stitching for emphasis and added texture using the photograph as a guide for placement, shape and color.

Arcadia Taking Tea
1. Trace the template twice onto tracing paper. Make paper templates of all the shapes including the background and border strips.

2. Cut the backing piece adding ¹/₂ in/1.3cm turning-under allowance to each edge.

3. Cut the border strips adding ¹/₄ in/0.6cm turning-under allowance around all the edges. Cut the three background pieces adding ¹/₄ in/0.6cm turning-under allowance around all the edges.

4. Following the diagram opposite, sew together the three pieces that make up the background using ¹/₄ in/0.6cm seam

allowance. Leave small gaps along the top edge of the horizontal bar to allow the columns to be slipped in.

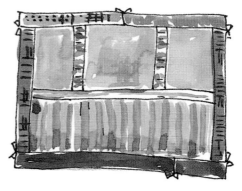

8. Sew the top and bottom borders to the background using ¹/₄ in/ 0.6cm seam allowance.

5. Appliqué the two striped columns to the background, slipping the bottom raw edges

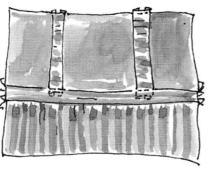

underneath the long striped horizontal bar. Slipstitch the gap closed.

9. Center the assembled background on the backing, wrong sides together.

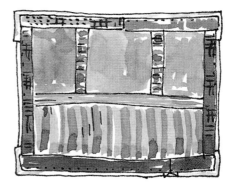

6. Attach the two side borders to the back-ground using ¹/₄ in/0.6cm seam allowance.

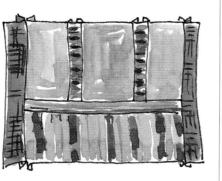

10. Turn under the edges of the background and turn in the edges of the backing to be just visible. Pin, then sew all the layers together using running stitch.

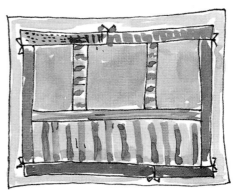

7. Sew each of the top and bottom borders using ¹/₄ in/0.6cm seam allowance.

11. Use your templates or cut out all the appliqué motifs, adding by eye a ¹/₄ in/0.6cm turning-under allowance around each shape.

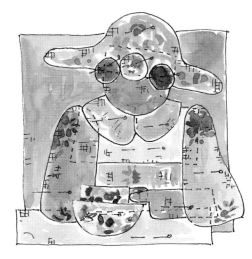

12. Using your template as a guide, position all the components of the woman on the background. Study the photograph and template carefully for placement and to work out which parts overlap.

13. Appliqué the shapes to the background in the following order: table, body, her right arm, her right

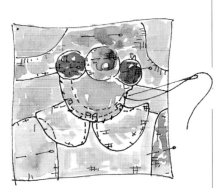

collar, left collar, face, hat, flowers on hat, cup handle, left hand, left arm, cup and finally the saucer. Remember not to turn under any edges that will be concealed by another shape.

14. Pin the pot in place, and tuck the flower stalks under the rim of the pot. Appliqué using the needle-turning method.

15. Using the photograph as a guide, pin, then sew the flowers in place.

16. Add the final top stitching for emphasis and added texture using the photograph as a guide for placement, shape and color. I used a variety of different colored threads for the face. You can trace the facial features from the template provided, or you may want to find another "face". Try your ideas first on a piece of scrap fabric.

Lily in the Tree House and *Iris Reading by the Summer House*

1. For "*Lily*" and "*Iris*" follow the directions as for *Arcadia Taking Tea.* Study the photographs and templates of each picture carefully to understand the order in which each shape is sewn down.

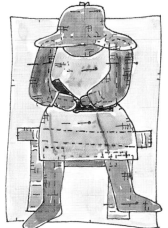

2. The crease of the bent arm will happen with a little coaxing as you sew the arm down.

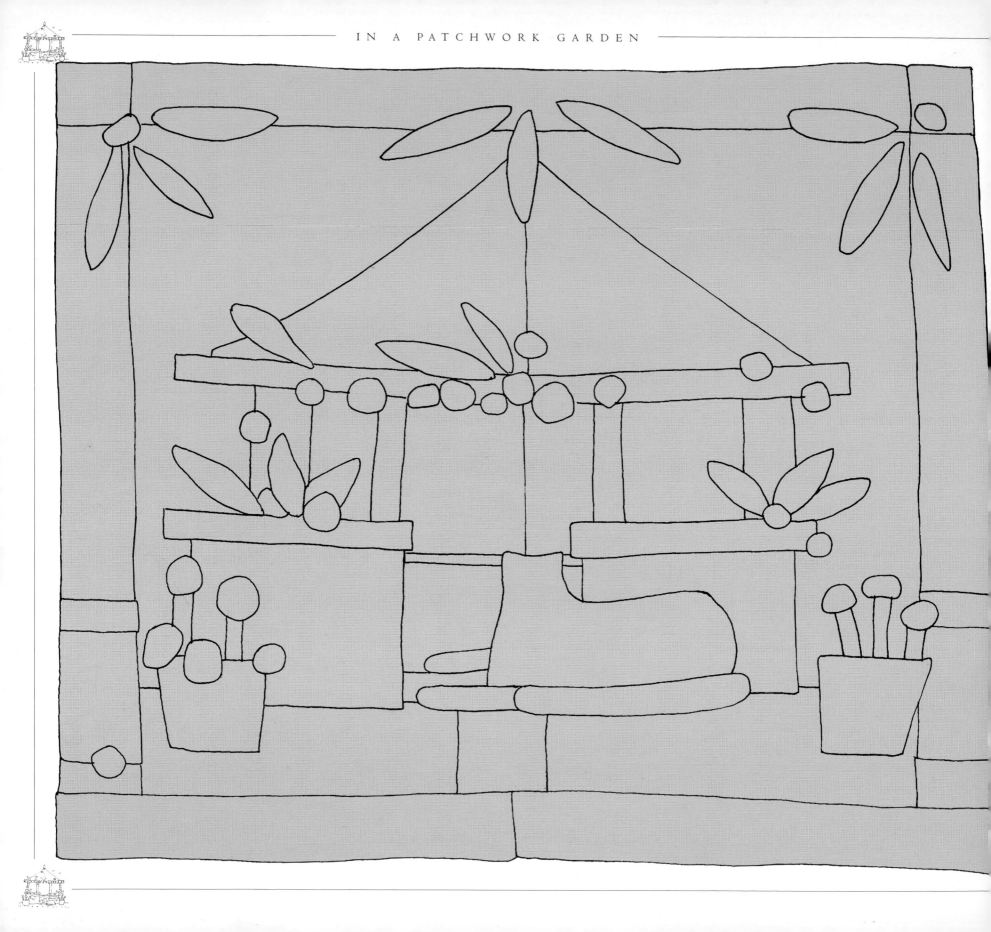

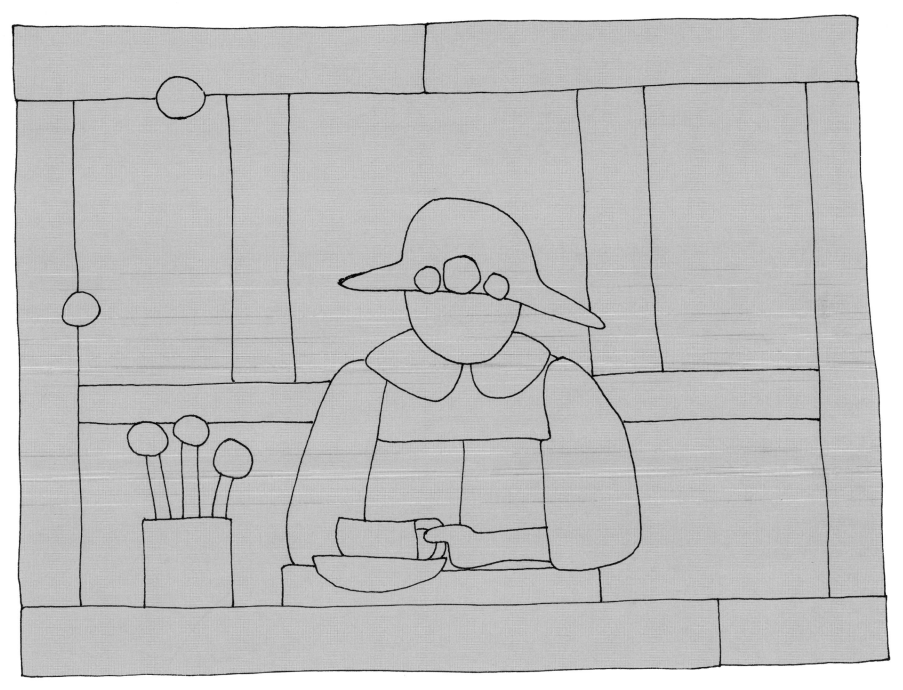

Left: *Cat by the Summer House template* Above: *Arcadia Taking Tea template*

61

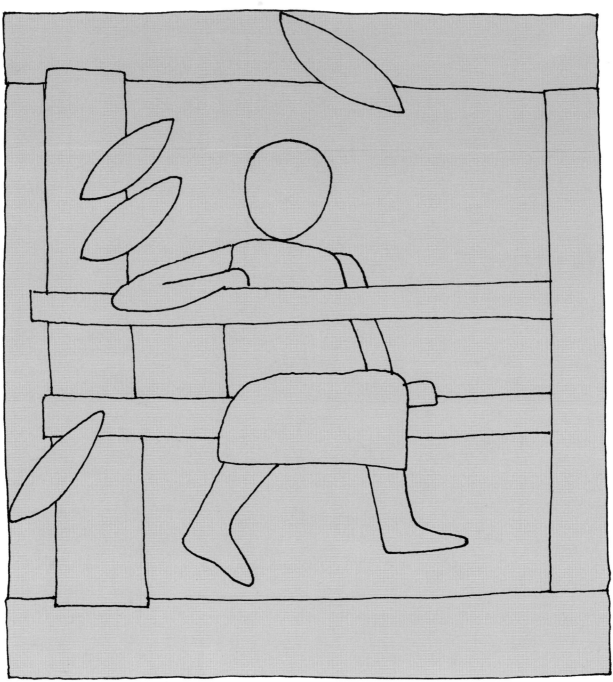

Lily in the Tree House template

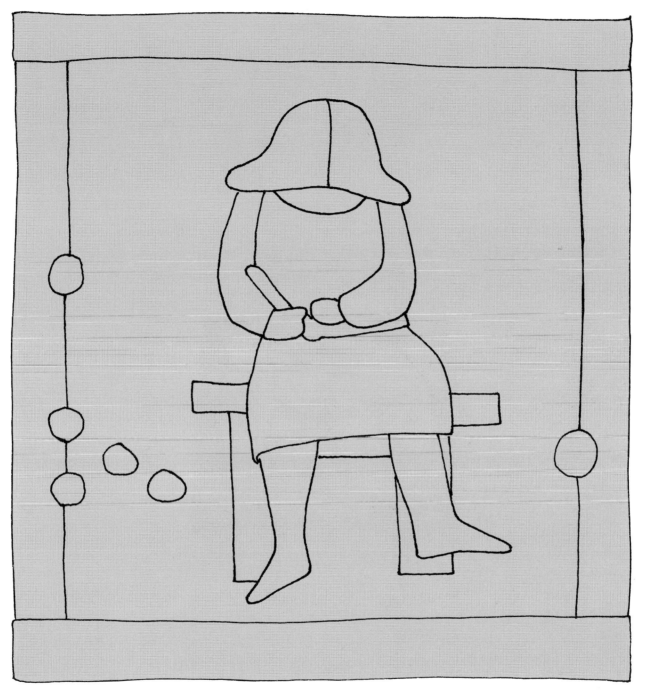

Iris Reading by the Summer House template

HERB GARDEN

The herb garden can provide delight for all the senses throughout the seasons. In spring it provides a profusion of wonderful aromatic smells, in summer it offers color and texture and in winter, bunches of dried herbs can be hung in a kitchen to provide pleasure to the eye as well as flavor food. I think that if I had only the tiniest of places in which to grow plants some herbs would be amongst them.

When grown in the traditional knot garden, the appearance of the bedding area is visually important, if not more so than the individual plants. Each section is delineated by a small box hedge carefully and meticulously trimmed to retain its crisp geometry. This idea in itself would provide the strong basis for a successful picture. One small stem or flower of various herbs could indicate the planting.

The plants can be successfully grown in a more humble environment, each one placed in its own pot. These pots can then be arranged in a pleasing way both in a picture or in real life, on a windowsill or patio, indoors or out.

As for the plants, they each encompass a whole range of human experience; from curing our ills, exciting our palette, to perfuming our houses and belongings.

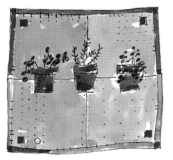

Rosemary

Basil

Parsley

Dill

Marjoram

Mint

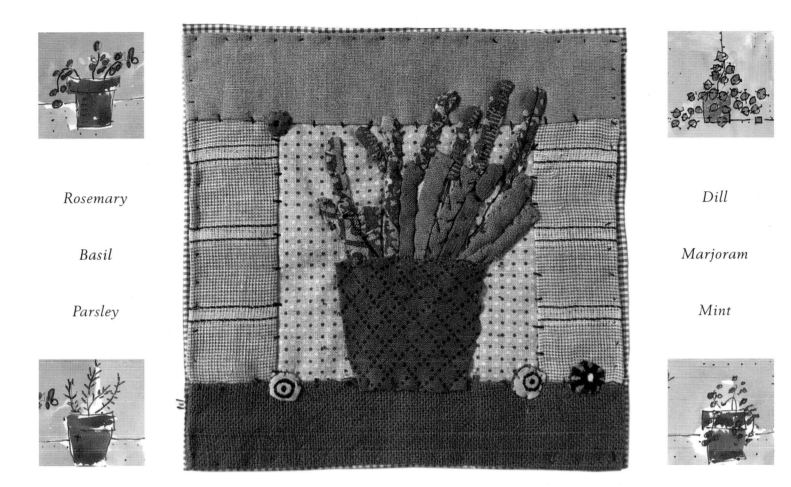

The Pot of Lavender

Consider just one prolific and for the gardener often difficult to control plant–mint. It can link us to experiences ranging from the mundane to the mythological. As early as the fourteenth century mint is recorded as being used to whiten teeth. (Before discovering this, I had always assumed it was used for the fresh taste alone.) In Greek mythology, Menthe, beloved of Pluto was metamorphosed into the plant we know today by Proserpina who was jealous of Pluto's attentions to her. For health Culpepper lists nearly forty illnesses for which mint is "singularly" good.

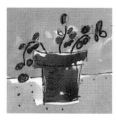

Horseradish

Fennel

Thyme

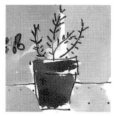

Tarragon

Borage

Sage

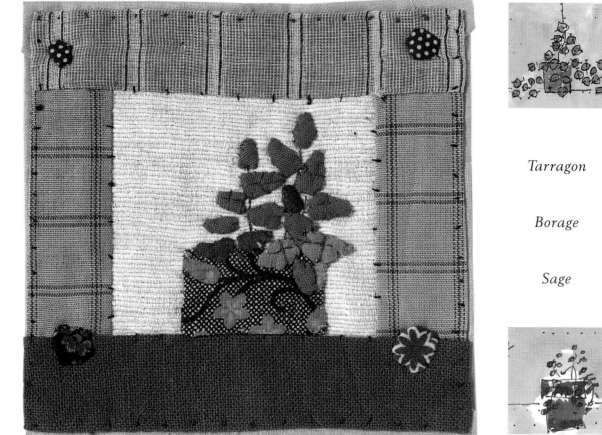

The Pot of Sage

To make my herb garden fit into the quilt I decided to depict separate plants placed in a formal square. This simple idea solved a variety of design considerations. For one, the squares formed a direct link with the topiary squares which I had already decided upon, and made a strong satisfying frame to the quilt. Secondly, depicting each plant this way helped solve the problem of working with cut out shapes of color to depict plants which often have very small leaves and flowers and are rich in linear detail. Placing these plants in this way also pleased me because the geometric shapes reminded me of knot

66

gardens, in which each plant is carefully placed in a formal setting.

I don't worry about botanical accuracy in my pictures. My lavender bush and sage plant are suggestions of the plants only. It is enjoyable and useful to study plants carefully before making sketches and small paintings. Look at the way in which plants grow so that you can reproduce a more realistic picture if you wish to. The knowledge is helpful when deciding which aspects to emphasize when creating fabric pictures.

Rosemary

Mint in flower

Mint

MAKING THE HERB GARDEN

MATERIALS

Use the template as a guide for fabric quantities, remembering to add $1/4$ in/0.6cm turning-under allowance to all shapes and $1/2$ in/1.3cm allowance for the backing.

- Plain cotton or curtain lining for backing
- Plain cotton or curtain lining for background
- Fabric strips suitable for borders
- Selection of fabric scraps for the plants and pots
- Green bead for *The Pot of Lavender* picture
- Sewing cotton, needles, pins, scissors

MAKING UP
The Pot of Sage

1. Trace the template twice onto tracing paper. Make paper templates of all the shapes including the background and border strips.

2. Cut the backing piece adding $1/2$ in/1.3cm turning-under allowance.

3. Cut the border strips adding $1/4$ in/0.6cm turning-under allowance around all the edges, then cut the background.

4. Following the diagrams below, sew the background and border pieces together using $1/4$ in/0.6cm seam allowance.

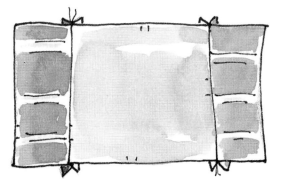

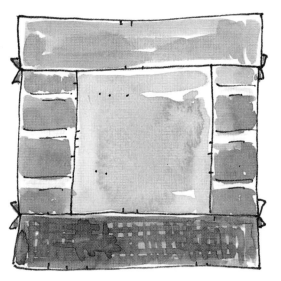

5. Center the assembled background on the backing, wrong sides together.

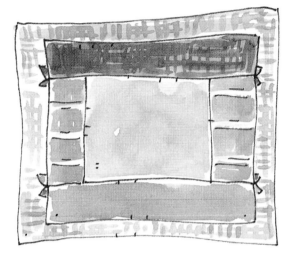

6. Following the diagram below, turn under the edges of the background and turn in the edges of the backing to be just visible. Pin the layers together, then sew through all the layers using a simple, long running stitch to give a distinct pattern of "dots" around the outside edge.

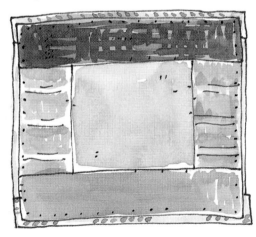

7. Using your templates or cut freehand, the corner flowers, the leaves and pot, adding by eye a 1/4 in/0.6cm turning-under allowance. If you are a confident sewer, cut a smaller allowance.

8. Pin the pot in place and secure with a small hemstitch.

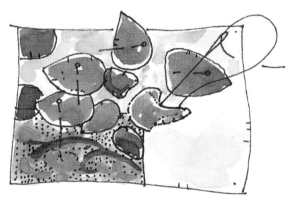

9. Position all the leaves and flowers using the template as a guide. When you are happy with the arrangement, pin, then appliqué in place using the needle-turning technique.

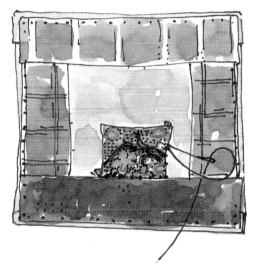

10. Using the photographs as a guide, add the final top stitching for emphasis and added texture. A simple couched line over some of the leaves, and a small running stitch "dot" along the inner border to echo the outer border will probably be plenty for such a small and simple picture.

The Pot of Lavender
To make *The Pot of Lavender* follow the directions for *The Pot of Sage* but sew the plant in position before the container. Also, unlike the sage plant in which none of the leaves over-lap, several of the lavender stalks overlap. Remember to turn under the edge of the top shape only when sewing overlapping shapes.

The Pot of Lavender
template

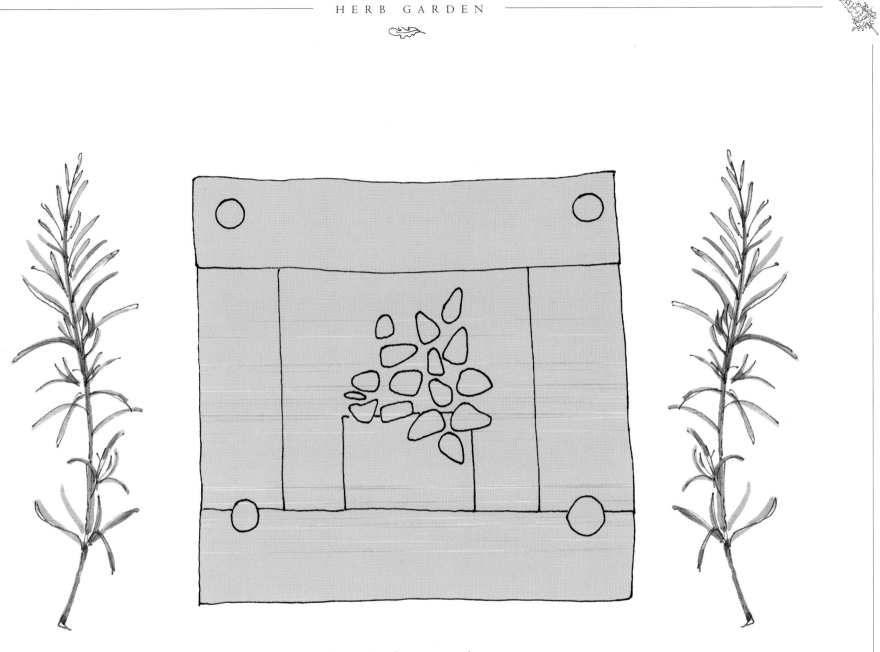

The Pot of Sage template

THE FISH POND

The addition of a pond to your garden can bring many pleasures, as well as offer a comfortable habitat for a host of wildlife which in turn will benefit your garden.

The grandest of land-scapes, a hit-and-miss cottage garden or a mani-cured suburban garden can each be enhanced by the play of reflected light, the movement and tran-quility that an ornamental water garden can pro-vide. And with the

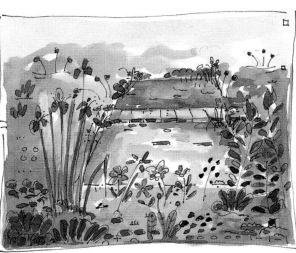

further addition of a small pump your garden can be enlivened with the melodies of running water.

Today most ponds are created for purely decorative reasons but there is a long and well-documented tradition of the pond being an important living larder, as well as providing drink for wild animals and domestic beasts.

A natural pond is a delicate and precarious world sustaining a vast number of different plants, insects and ani-mals. They are inclined to become overgrown and over-silted, and are vul-nerable to pollution of many kinds. So by adding a small pond to your gar-den you will have the pleasure of knowing that you are creating and caring for your very own miniature water environment.

When planning a garden, the different parts need to be designed to look pleasing in themselves, to relate and work together with the garden as a whole. Your color choices for

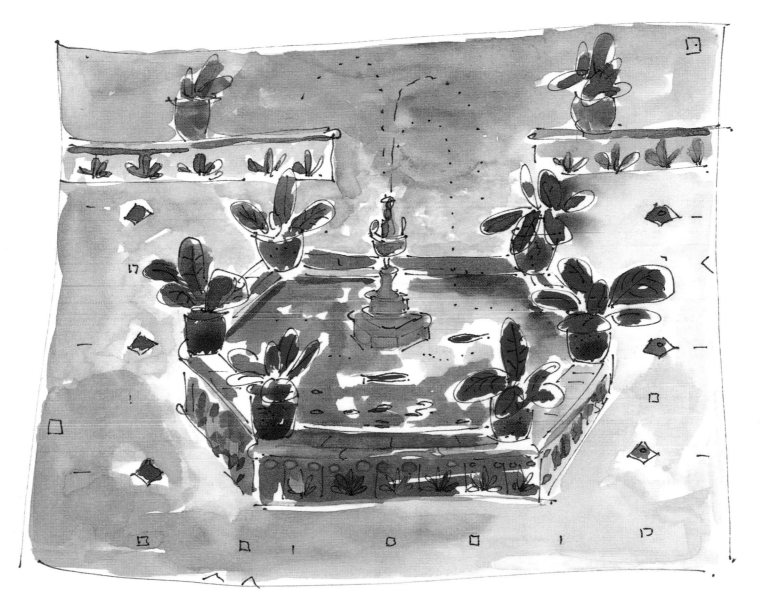

In a Spanish garden

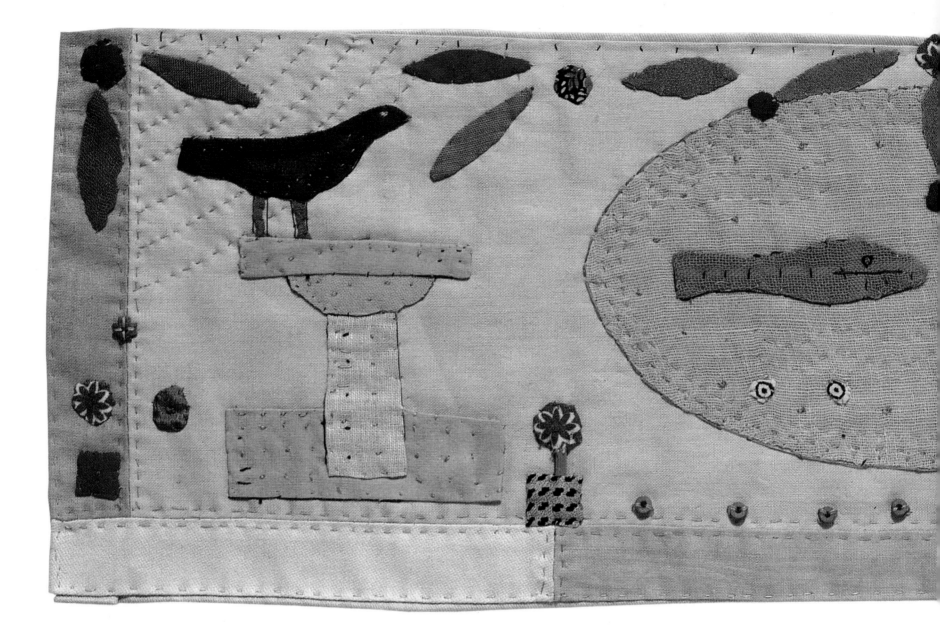

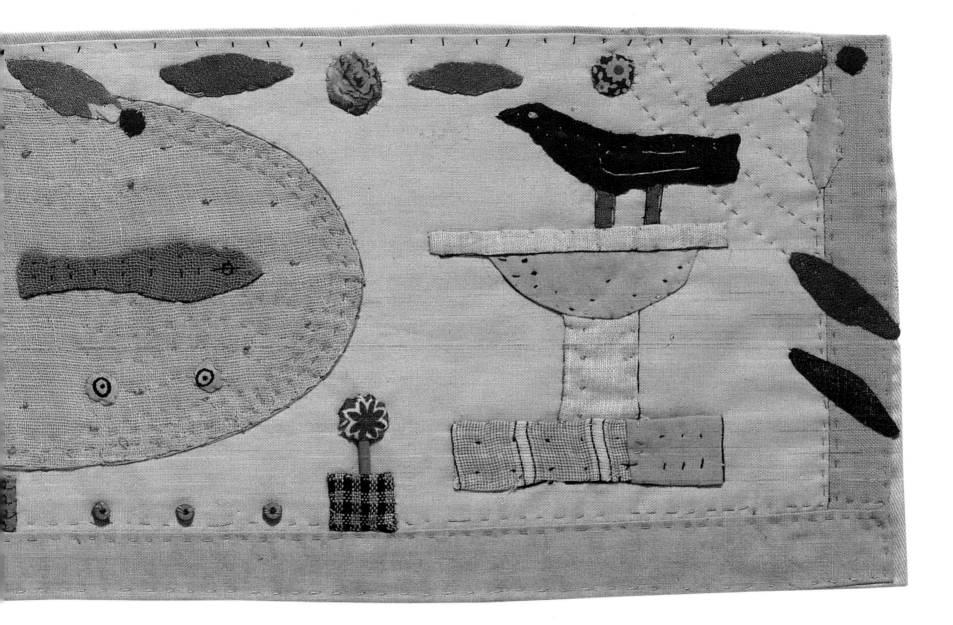

plants lead the eye from one area to the next and through all the garden. A very rich and densely planted area can be placed next to a spacious and airy part of the garden. Strong boundaries of paths and walls and edgings of all kinds can be used to separate and define areas as well as unite them.

My garden quilt has been designed and built up using exactly the same principles with attention to color and composition, and keeping an eye on how the parts relate to the whole.

I designed *The Fish Pond* after completing the central summer house panel, and I knew that I needed to find a composition that would balance the bold black cat and the architecture of the garden house. Firstly, I decided on the shape of the piece. To support the large and solid central piece I opted for a long rectangle which would place

emphasis on the horizontal design. For the composition I chose a very classical setting of an elliptical pond flanked by two well-shaped bird baths. On top of each bird bath I have placed a large, somewhat over-sized bird.

Before embarking on this piece I made numerous sketches of natural ponds and water gardens. I made paper collages with pond related images that I had cut out of magazines. I looked carefully at plants, their shapes and colors and the effect that the surrounding water had on their appearance.

The watercolor painting on page 73 was not intended to be worked in fabric, however it did offer a starting point for new ideas and on the following page you can see the transition to the simpler shapes that could well be adapted for stitching into a fabric picture.

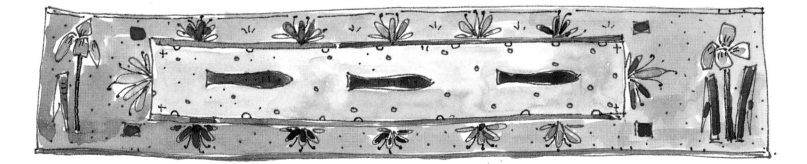

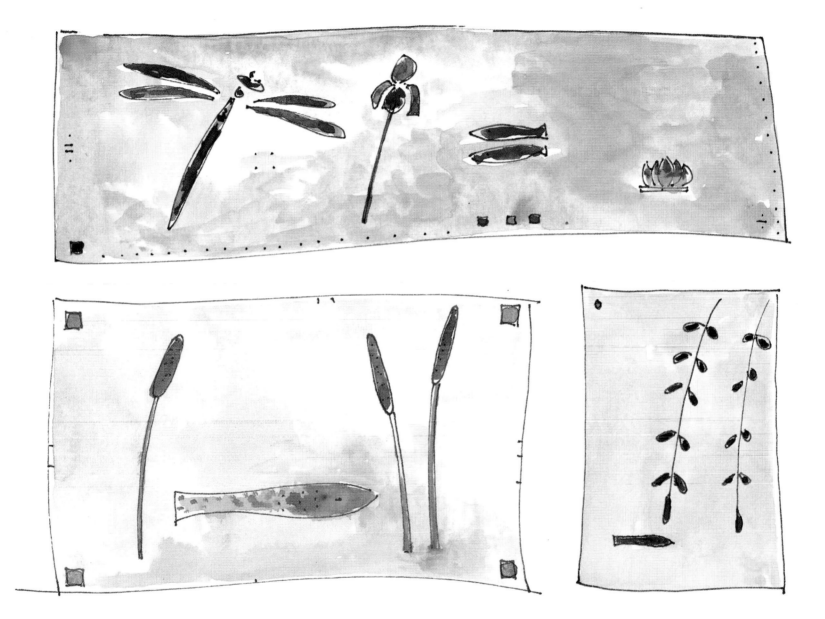

Sketches that could easily be translated into fabric pictures

MAKING THE FISH POND

The Fish Pond

MATERIALS

Use the template as a guide for fabric quantities, remembering to add ¹/4 in/0.6cm turning-under allowance to all shapes and ¹/2 in/1.3cm allowance for the backing.

- Plain cotton or curtain lining for the backing and the background
- Assorted scraps of cotton, muslin and silk for appliqué motifs and borders
- Assorted beads
- Fine basket cane and watercolor paint
- Sewing thread, needles, pins, scissors

MAKING UP THE PICTURE

1. Trace the template twice and make paper templates of all the appliqué shapes including the background and border strips.

2. Cut the backing piece adding ¹/2 in/1.3cm turning under allowance. Cut the border strips and background adding ¹/4 in/0.6cm turning-under allowance.

3. Following the diagrams, stitch the borders to the background. Turn under a ¹/4 in/0.6cm seam around each side.

4. Press a ¹/4 in/0.6cm seam on all four sides to the wrong side of the backing cloth.

5. Center the background right side up on the wrong side of the backing cloth.

6. Sew the two pieces together using a running stitch.

7. From the templates provided cut out all the appliqué shapes, remembering to include a ¼in/0.6cm seam allowance all around.

8. Position all shapes, and when you are happy with the arrangement, pin them in place.

9. Using the needle-turning technique appliqué all the motifs to the background. Where shapes overlap secure only the top shapes.

10. Cut the basket cane into short lengths for the flower stalks. Add a little color with a quick touch of paint and when dry, secure in place with a couching stitch.

11. Add the beads at this stage. Use my picture as a guide only. You may have a wonderful collection of beads that might look quite wonderful in this setting.

12. Finally, using a variety of stitches, such as couching, French knots and running stitch adds definition or emphasis to any part of the picture you consider needs further attention. Quilt the pond lightly to indicate ripples of water.

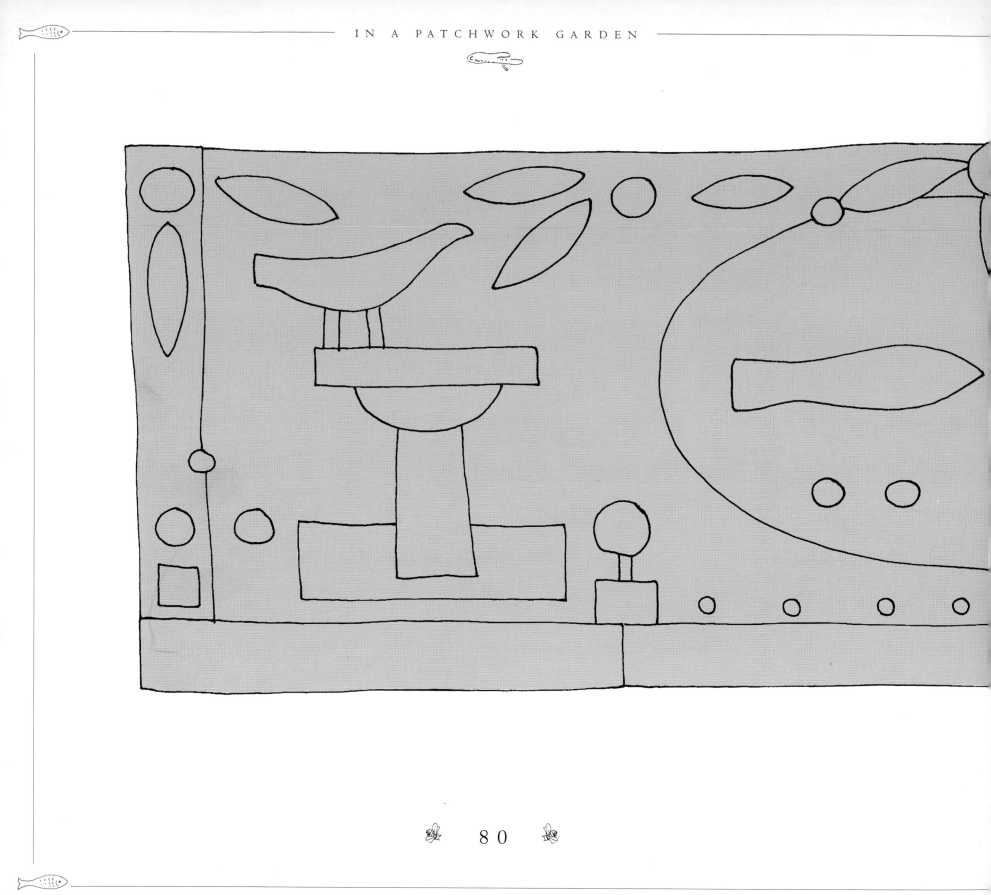

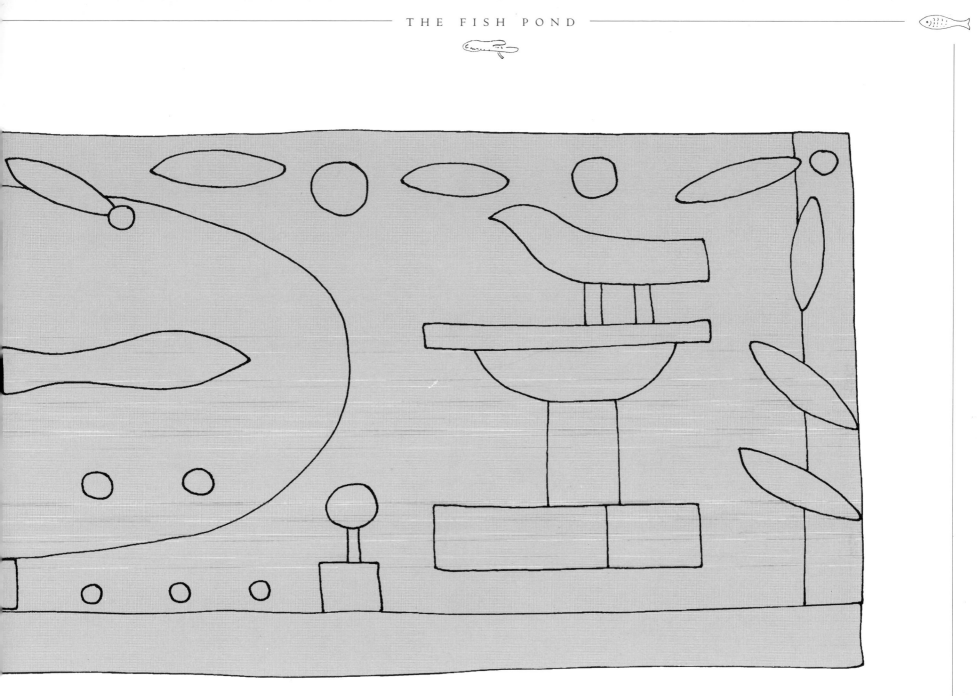

The Fish Pond template

THE ROSE GARDEN

The rose must be one of the most well-loved and used images of all time, at least among cultures where it is known. It is hard to think of any object, from a huge building on which the image is carved in stone to the smallest button, that has not been embellished with a rose motif.

Cultivated since ancient times, the rose has traditionally been used as a symbol of love. The Romans adorned images of Venus and Cupid with roses. The architects of the great gothic cathedrals used the rose image for stained glass windows and surface sculpture. Artists and artisans, sacred and secular; poets and balladeers throughout the ages have used the rose as an image of love.

O, *my Luve's like a red red rose*
That's newly sprung in June:
O *my Luve's like the melodie*
That's sweetly play'd in tune.

At the stately home Villandry on the Loire in France, a standard rose has been planted in one corner of the Rose Garden to represent a monk hoeing his section of the garden. Obviously you would have to be told of this significance to appreciate it. Similarly objects in many paintings have a hidden and symbolic meaning that the uninitiated would need to be told about to understand the intention of the artist. When planning a garden or a picture the placment of symbolic elements must be considered as part

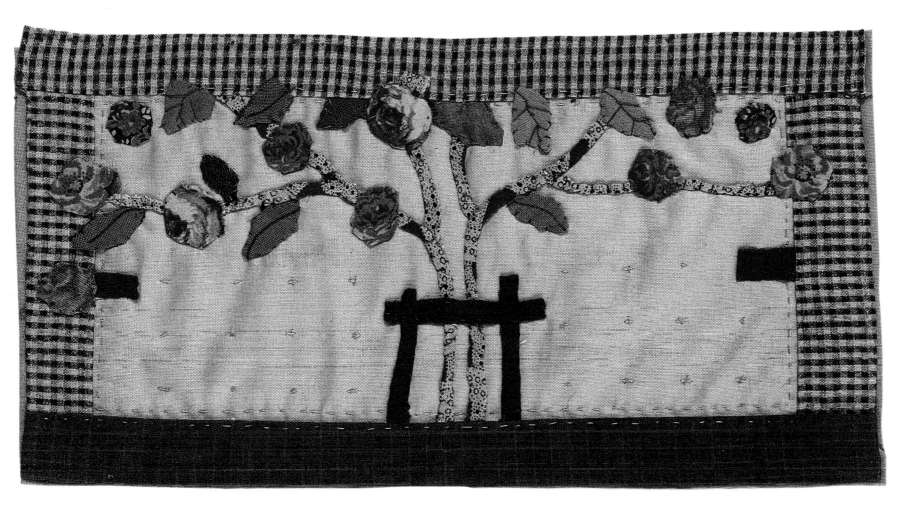

The Rose Garden

of the overall visual design. It isn't essential to be aware of the symbolism to appreciate the picture, but such knowledge certainly enriches the experience. Hidden meanings or resonances are sometimes known only to the creator, the viewer bringing their own associations with them. The mood and feel of a garden, like the atmosphere of a picture can evoke a host of memories. Similarly, fabrics used can have a significance known

only to the owner. The fabrics that you choose for your pictures may have been at one time part of a favorite piece of clothing, your child's first dress, a gift from a friend or found on a memorable holiday. These type of associations inevitably will enrich your work.

The roses at Villandry were reputed to have come from India at the time of the Crusades. It is fascinating to follow the history and geographical journeys of plants. For inspiration for future pictures, take the rose and look for its depiction throughout history and in different cultures. Look out for how many different fabrics you can find using the rose motif. Some of your finds may serve as blooms in your picture.

For *The Rose Garden*, I wanted to create a piece that was sympathetic in shape to *The Fish Pond* that I had made earlier. This would give a sense of balance to the finished quilt. I chose a standard rose, trained in an espalier fashion. Its long reaching branches echo the strong horizontal line of the pond above. By using a wooden support for the growing rose I was also able to recall the architectural structure of the summer house. When conceiving a large picture made up of many small components, it is essential to find several common compositional and color elements. A sense of harmony will only be created if the individual panels sit comfortably together.

Left and right: *Rose sample swatches*

MAKING THE ROSE GARDEN

MATERIALS

Use the template as a guide for fabric quantities, remembering to add ¼ in/0.6cm turning-under allowance to all shapes and ½ in/1.3cm allowance for the backing.

- Plain cotton or curtain lining for the backing
- Plain cotton or curtain lining for the background
- Fabric strips suitable for borders
- Selection of fabric scraps for the roses, leaves, branches and supports
- Sewing cotton, needles, pins, scissors

MAKING UP

1. Trace the template twice onto tracing paper. Make paper templates of all the appliqué shapes including the background and border strips.

2. Cut the backing piece adding ½ in/1.3cm turning-under allowance.

3. Cut the border strips adding an extra ¼ in/0.6cm turning-under allowance around all the edges, then cut the background.

4. Following the diagrams below, sew the background pieces together using ¼ in/0.6cm seam allowance.

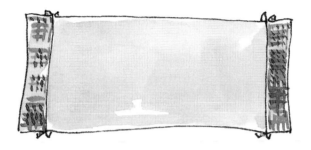

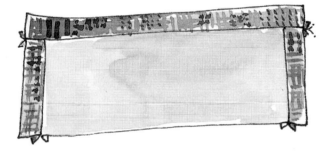

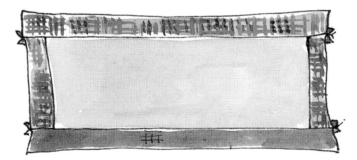

5. Center the background on the backing, wrong sides together.

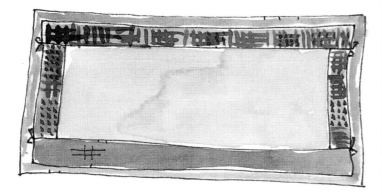

6. Following the diagram below, turn under the edges of the background and turn in the the edges of the backing to be just visible. Pin all the layers together, then sew using a simple running stitch.

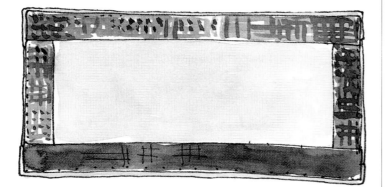

7. Use your templates or cut freehand, the flowers, leaves, branches and supports, adding by eye a 1/4 in/0.6cm turning-under allowance.

8. Pin the branches in place, then slipstitch to secure. To define the curving shape of the branches, start with a straight edge, secure the turn-under with a couple of small stitches, then ease fractionally different amounts of fabric under before sewing in place.

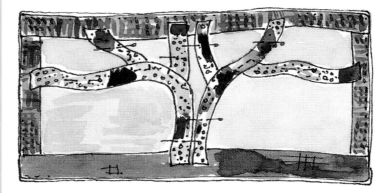

9. Pin, then sew the flowers, leaves and supports in position.

10. Using the picture as a guide, appliqué the small squares to either side of the panel and add the final stitching details. I used a couched line to represent the veins in each of the leaves.

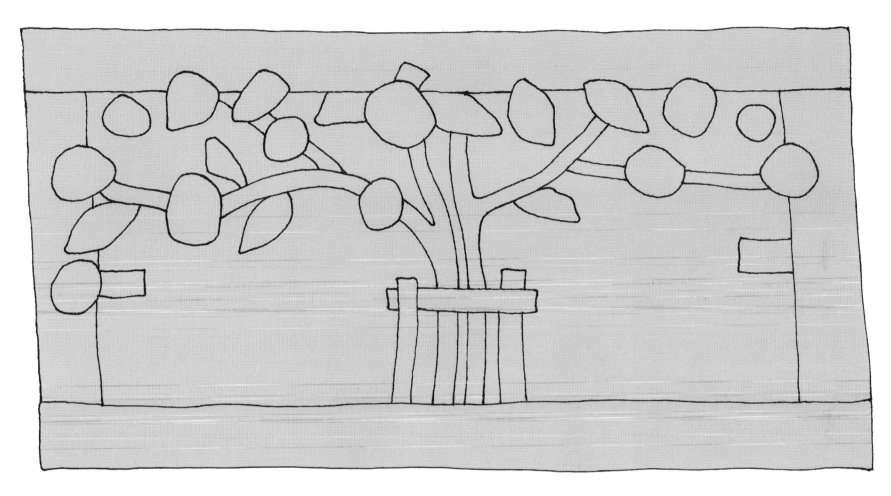

The Rose Garden template

TOPIARY

The word topiary comes from the Latin which means landscape gardening or painting. The art of clipping shrubs and trees into ornamental shapes was practiced by the Romans. There are records of Box Tree and Rosemary being cut to shape in medieval gardens, and by the late sixteenth century topiary was popular throughout Europe. Peacocks, mermaids, birds and animals, as well as geometric shapes such as pyramids,

obelisks, cones, domes, spirals, cubes and balls were fashioned from Box, Juniper, Whitethorn, Laurel, Yew, Cypress, Holm Oak

and Privet. Just as a garden is man's attempt to shape nature to follow his precepts and rules, so too does topiary seem to fulfill a deep human need to control the natural world.

Well-established and carefully maintained topiary gardens are magical. The instruments used to prune these shapes, ladders, taut strings and plumb lines have a measured mathematical quality that I find fascinating. I had them in mind when choosing the grid-like background fabrics on which to place my topiary shapes. The formal square shapes placed symmetrically

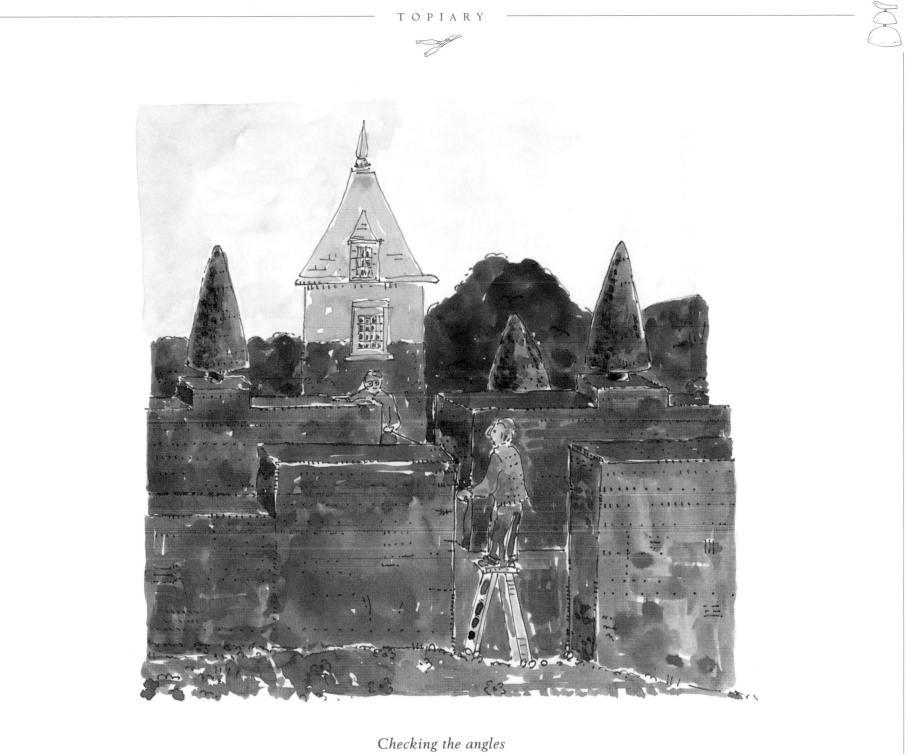

Checking the angles

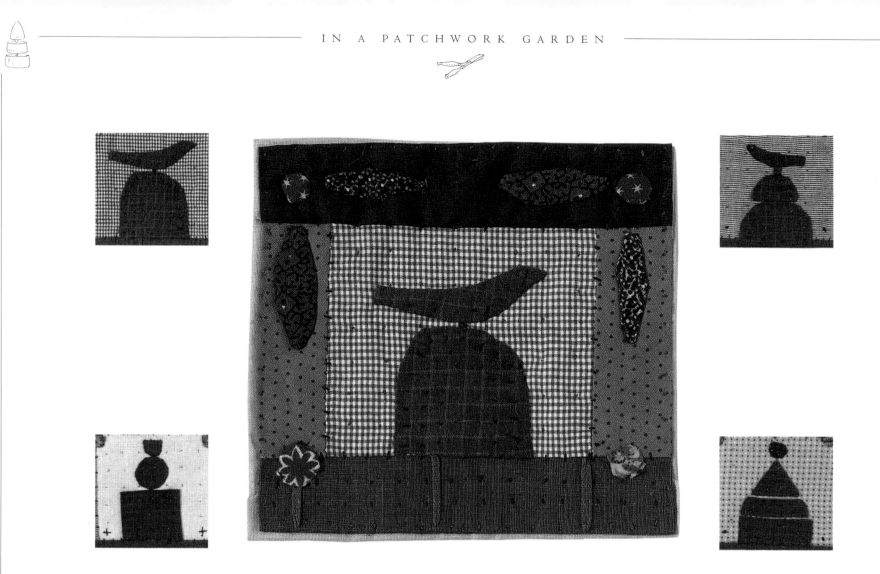

Large Bird

opposite each other echo this controlled calm quality that I enjoy. At the same time they provide a strong frame for the whole quilt. What is possible to accomplish with topiary and what it is possible to accomplish with appliqué work makes for a straightforward design translation. In both cases, the placement of the shapes is the most important consideration for a successful design.

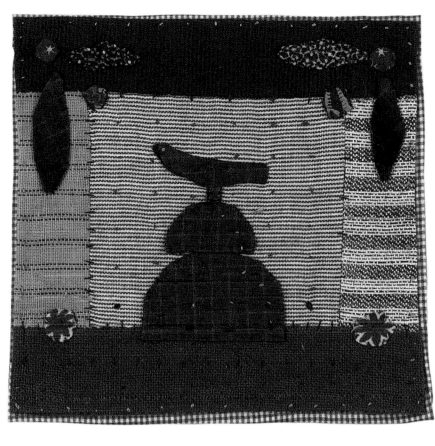

Small Bird

Placing topiary shapes together can create optical illusions. With natural perspective, objects look smaller in the distance. This can be exaggerated by placing smaller and yet smaller bushes going into the dis-tance making the horizon look further away than it really is. Or, by placing the smaller shapes to the foreground and the larger ones in the distance the illusion of perspective can be reversed and

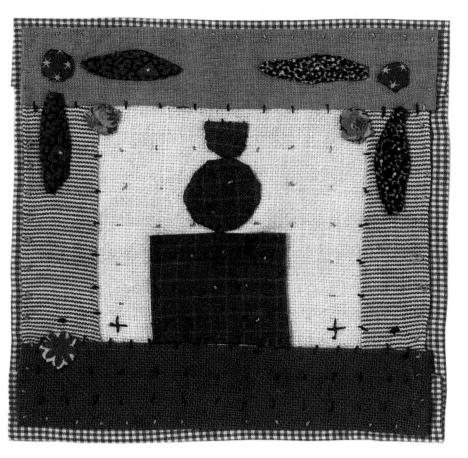

Geometric

results in bringing the horizon nearer.

This arrangement can be used to make an avenue look twice as long when viewed from one end, as when viewed from the other—

delightful magic. Illusions can be created in both gardens and pictures by such simple devices.

Topiary is out of the question in many gardens but some form of the art can be practiced. The most

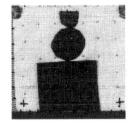

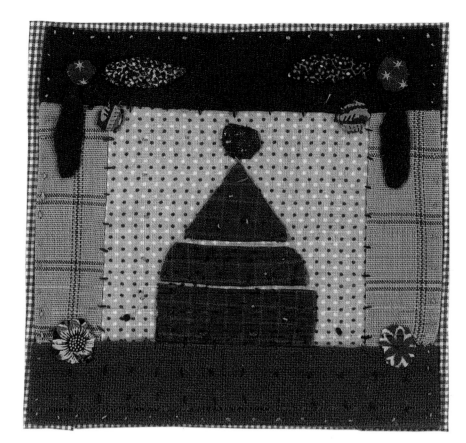

Obelisk

often seen must be the lollipop bay trees that grace many an entrance. In this quilt they can be seen by *The Fish Pond*. Another way to emulate topiary without the need for large bushes and lots of spare time is to buy from a good garden center one of the metal frames fashioned into topiary shapes, and train ivy or other small-leaf plants to grow over them.

MAKING THE TOPIARY

Large Bird
Small Bird

Obelisk
Geometric

All four topiary can
be made up in the same way.

MATERIALS
Use the template as a guide for fabric
quantities, remembering to add $^1\!/_4$ in/0.6cm
turning-under allowance to all shapes and
$^1\!/_2$ in/1.3cm allowance for the backing.
- Plain cotton or curtain lining for the
 backing
- Plain cotton or curtain lining for the
 background
- Fabric strips suitable for the borders
- Selection of fabric scraps for the topiary
 shapes
- Sewing cotton, needles, pins, scissors

MAKING UP
1. For each topiary, trace the template twice
onto tracing paper. Make paper templates of
all the shapes including the background and
border strips.

2. Cut the backing piece adding $^1\!/_2$ in/1.3cm
turning-under allowance.

3. Cut the border strips adding $^1\!/_4$ in/0.6cm
turning-under allowance around all the
edges, then cut the background.

4. Following the diagrams below, sew the
background pieces together using $^1\!/_4$ in/0.6cm
seam allowance.

5. Center the assembled background on the backing, wrong sides together.

6. Following the diagram below, turn under the edges of the background and turn in the edges of the backing to be just visible. Pin all the layers together, then sew through all the layers using a simple running stitch.

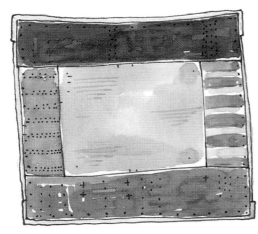

7. Use your templates or cut freehand, the topiary, flower and leaf shapes, adding by eye a 1/4 in/0.6cm turning-under allowance.

8. Turn under the seam allowance, then pin the shapes in place. Slipstitch to secure.

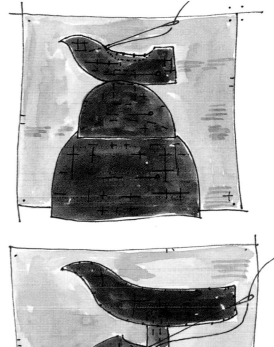

9. Pin, then sew the corner leaves and flowers in position.

10. Add the final top stitching for emphasis and added texture.

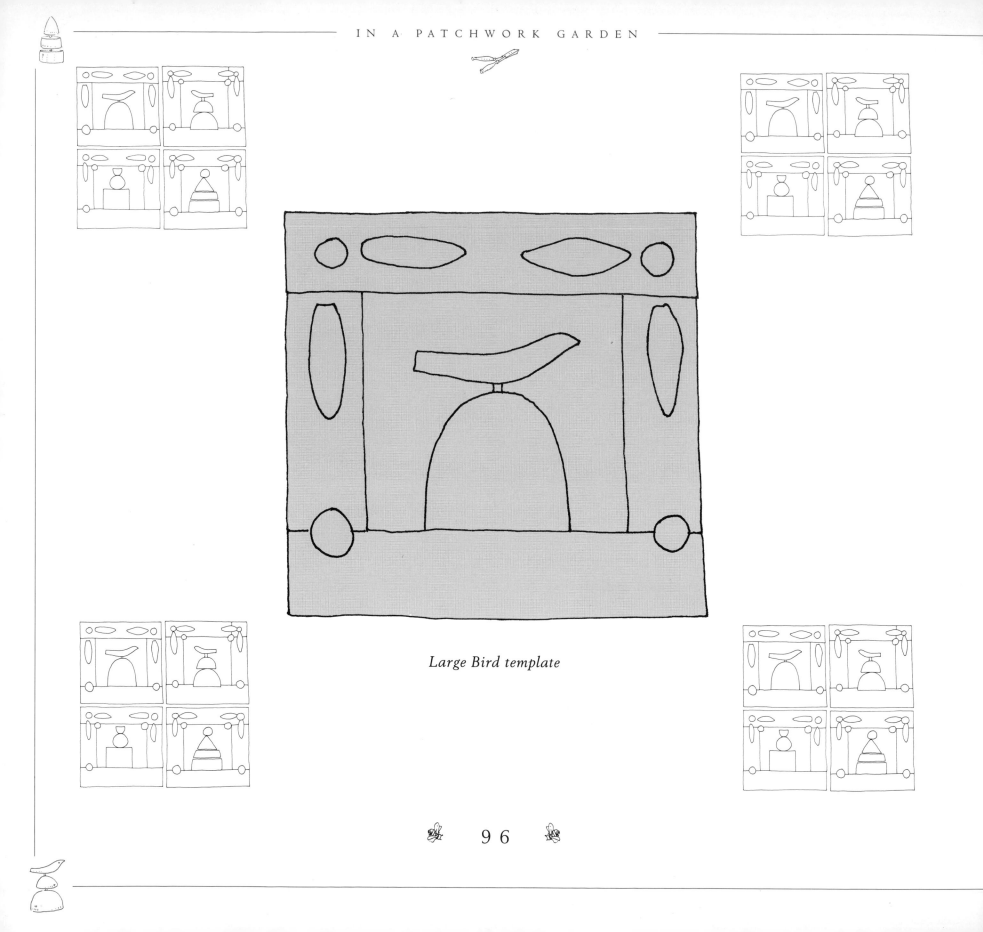

Large Bird template

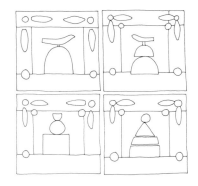

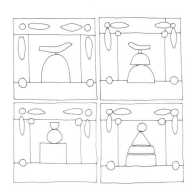

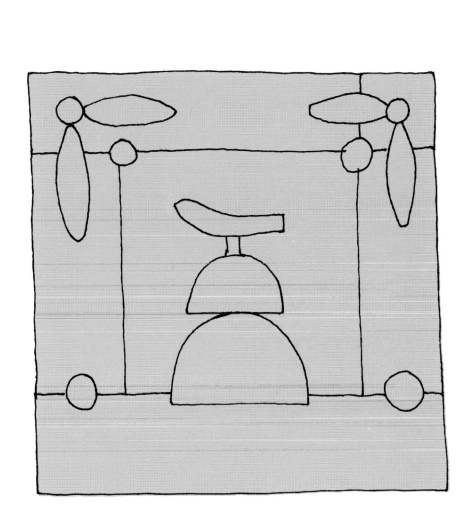

Small Bird template

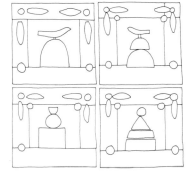

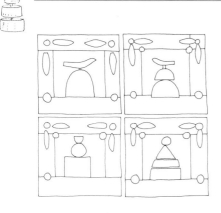

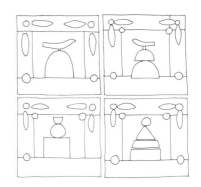

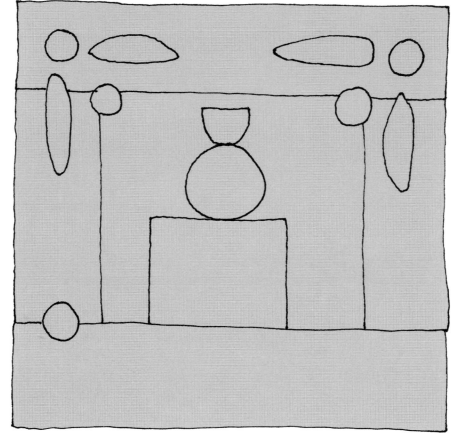

Geometric template

Obelisk template

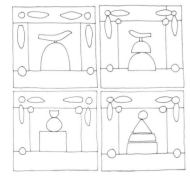

GARDEN ORNAMENTS

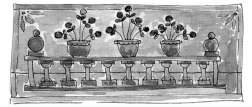

Balustrades are often beautiful structures and can be used to great effect to define certain parts of the garden. They provide a useful visual stop, between paved, lawn and planted areas, and are the perfect device for controlling different levels within one garden. Slopes can be difficult to plant, so a balustrade can provide the necessary support against which an area can be dug out to form a terrace.

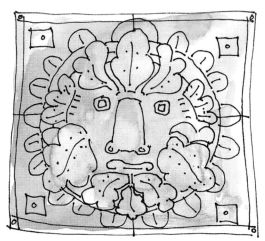

A balustrade overgrown with plants can create a dramatic visual break, one kept free of plants provides an intriguing screen through which to glimpse framed sections of the garden. Looking at small sections isolated in this way can be very helpful when planning a picture. It is interesting to carry your own "frame" around with you. Cut a "window" to any proportion you like, a square or a rectangle, a manageable size is a postcard with an aperture of 2 x 3in/5 x 7.5cm. Hold it about 12 in/30.5 cm in front of your eyes and move it around. Compositions will be created in front of you which you can then use as a starting point for a new idea.

As in the quilt, balustrades are often used to support garden ornaments placed at strategic points along its length. The placing of statues and

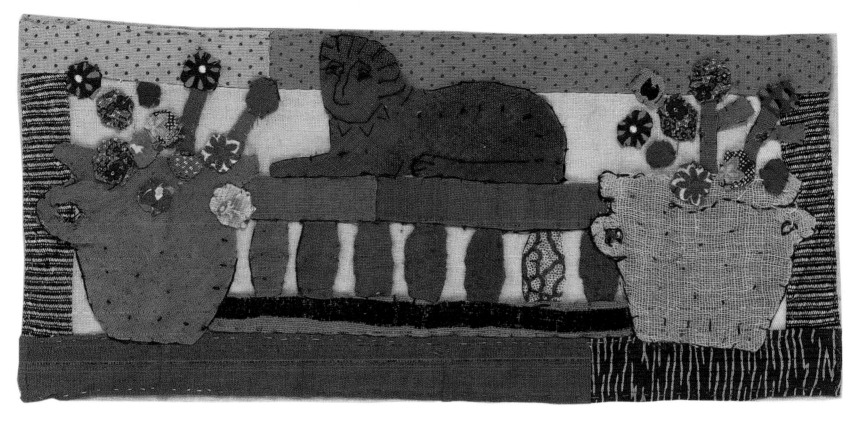

The Lion

other ornaments in a garden can tell us about the aspirations of the gardener. It isn't unusual to see the smallest dwellings with an entrance incongruously guarded by a pair of imposing figures proclaiming the owners pride of possession. Garden ornaments range from romantic cupids and angels, magnificent mythical beasts, Greek and Roman

figures to gnomes and miniature windmills. On a grand scale they serve to emphasize the magnificence of an establishment particularly when placed to enhance entrances and avenues.

The use of garden statuary was made popular by designer Sir Charles Ishem in the nineteenth century. Author of *Notes on*

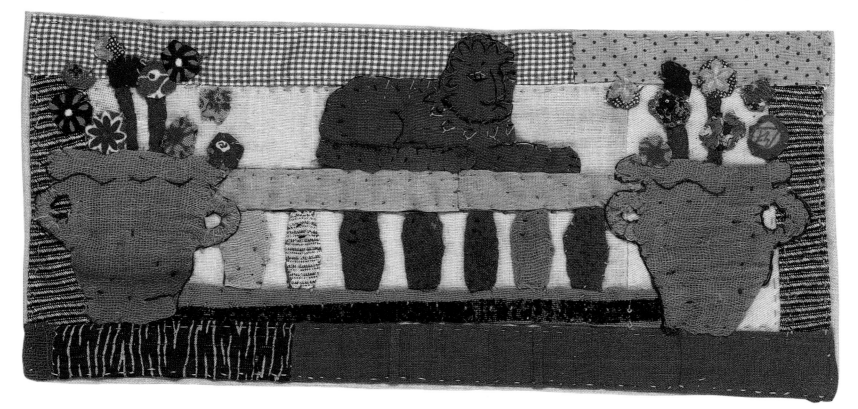

The Lioness

Gnomes, he was responsible for bringing the ubiquitous ornament to England from Germany. Garden centers today carry all forms of statuary from the regal lion to the cute hedgehog. Each can be placed immediately to please the gardener's plan–no waiting for them to grow or wondering if they will survive in that

particular position. Modern moulded concrete versions of traditional stone statues can be aged overnight with a color wash of paint or covered with yogurt which over the years will encourage plant growth and create a weathered effect. This may not, however be everyone's wish!

Sculptors have often created

gardens in which to place their work, such as the Barbara Hepworth garden in Cornwall, England. I will always remember driving through Connecticut and passing Alexander Calder's house. Placed in a woodland setting were his sculptures and mobiles, arranged just as a gardener would have positioned his precious plants.

For my garden quilt I restricted myself to two lions, placing them on the balustrade, each flanked by two large flower pots. The symmetry of their position balances the placement of the *Cat by the Summer House* picture. In conjunction with the balustrade they form a strong base for the overall quilt.

For *The Lion* I used the wrong side of a mottled fabric—the very subtle coloring suggesting weathered stone. I chose the soft brown color to complement the overall coloring of the quilt rather than a reference to any particular statue. The seated lion conveniently forms a simple shape for appliqué, and the carved features can be completed with a few couching stitches.

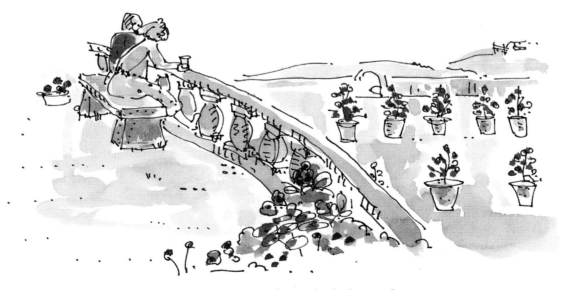

View from the balustrade

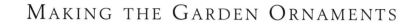

MAKING THE GARDEN ORNAMENTS

The Lion
The Lioness

MATERIALS
Use the templates as a guide for fabric quantities, remembering to add ¹/₄ in/0.6cm turning-under allowance to all shapes and ¹/₂ in/1.3cm allowance for the backing.

- Plain cotton or curtain lining for the backing
- Plain cotton or curtain lining for the background, use two contrasting neutral-colored fabrics for *The Lioness*
- Fabric strips suitable for borders
- Selection of fabric scraps for the lions, balustrade, pots, flowers and leaves
- Sewing cotton, needles, pins, scissors, tracing paper

MAKING UP
The Lion

1. Trace the template twice onto tracing paper. Make paper templates of all the shapes including the background and border strips.

2. Cut the backing piece adding ¹/₂ in/1.3cm turning-under allowance.

3. Cut the border strips adding ¹/₄ in/0.6cm turning-under allowance around all the edges, then cut the background.

4. Following the diagrams below, sew the background and border pieces together using ¹/₄ in/0.6cm seam allowance.

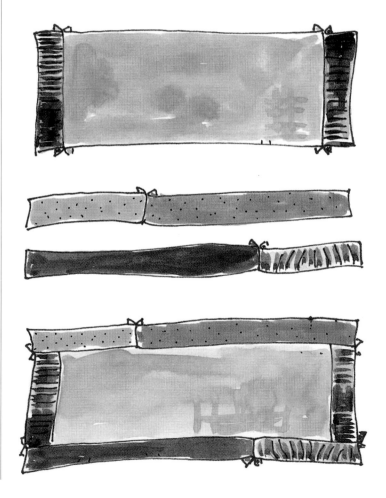

5. Center the assembled background on the backing, wrong sides together.

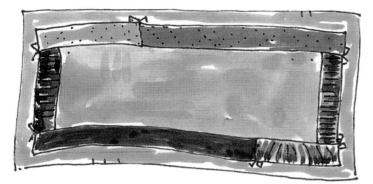

6. Following the diagram below, turn under the edges of the background and turn in the edges of the backing to be just visible. Pin all the layers together, then sew using a simple, long running stitch. This will give a distinct pattern of "dots and dashes" around the outside edge.

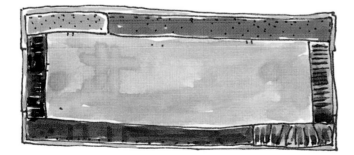

7. Use your templates or cut freehand, all the appliqué motifs, adding by eye a 1/4 in/0.6cm turning-under allowance around each shape.

8. Using your templates as a guide, mark the positions for each of the seven pillars. Pin, then appliqué the sides only in place. The top and bottom will be covered with the rail and base. The base is made up of two strips. Sew the pale colored strip on first, then appliqué a narrower dark strip on top.

9. Sew together the two contrasting brown strips for the rail, then appliqué in position to cover the raw edge of the pillars.

10. Pin the pots in place to cover the ends of the balustrade. Tuck the flower stalks under the rim of the pot. To define the handle shapes, cut a small hole in the handles, turn the raw edge under and sew to secure. You may find it easier to do this step before pinning the pots in place.

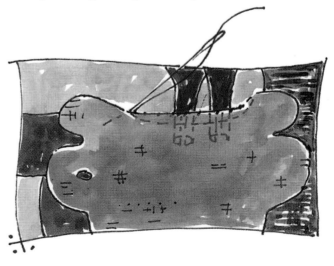

11. Using the photograph as a guide, pin, then sew the flowers and leaves in place.

12. Pin the lion on the rail and appliqué to the background, using the needle-turning technique. Define the shape and features with couched lines.

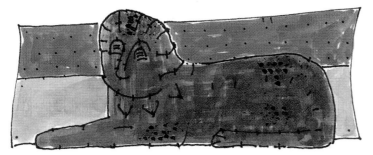

13. Add the final top stitching for emphasis and added texture using the photograph as a guide.

The Lioness
To make *The Lioness* follow the directions for *The Lion*. Remember to sew together the two background pieces before adding the border strips. Also, unlike *The Lion* which is cut from a single piece of fabric, *The Lioness* is made up of two separate pieces. I used three different embroidery floss colors to stitch her features and details.

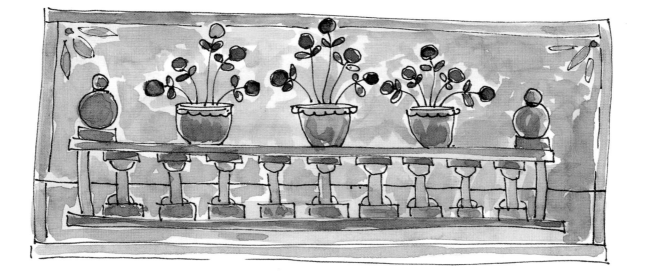

Above: Pots on a balustrade Opposite top: The Lion template Opposite bottom: The Lioness template

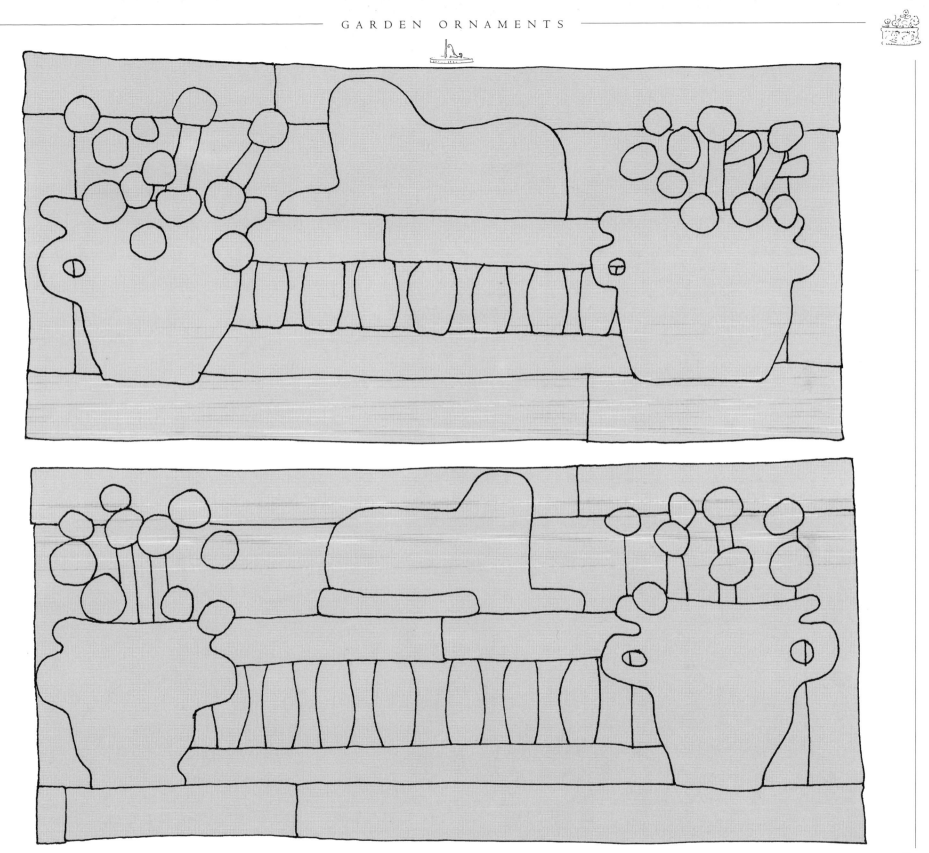

PATHWAYS

When working with applied shapes it is impossible and not desirable to be too concerned with exact shapes and measurements. Even on a carefully measured shape, shrinkage will occur as a result of quilting and decorative stitching. This is fine for individual pieces, however, if you intend to bring many pieces together to create a larger unit as I have done here, this can create its own set of problems.

My solution is to add additional borders and pathways between each picture. Just as pathways delineate and join one area of a garden to another I have envisaged them in the same way and used them to fill spaces between the pictures.

If you are considering making the whole quilt, lay all the pieces side by side, and in an arrangement you are happy with. Measure the gaps between the pictures and make up pathways to the size of your measurements. No two arrangements will be identical in size or shape, and so I have not provided templates for the pathways I made.

Garden pathways and edgings are a pleasure in themselves. Cinders, grass, pebbles, mosaics, old brick, stone, wood–the choice and variety are endless. Materials for pathways are an extremely important aspect of the overall plan for a garden and should be chosen with great care. Color, shape, pattern, texture, and design should each complement the garden and surrounding area. In the same way your choice of fabrics should blend harmoniously with the surrounding pictures and not draw attention away from them.

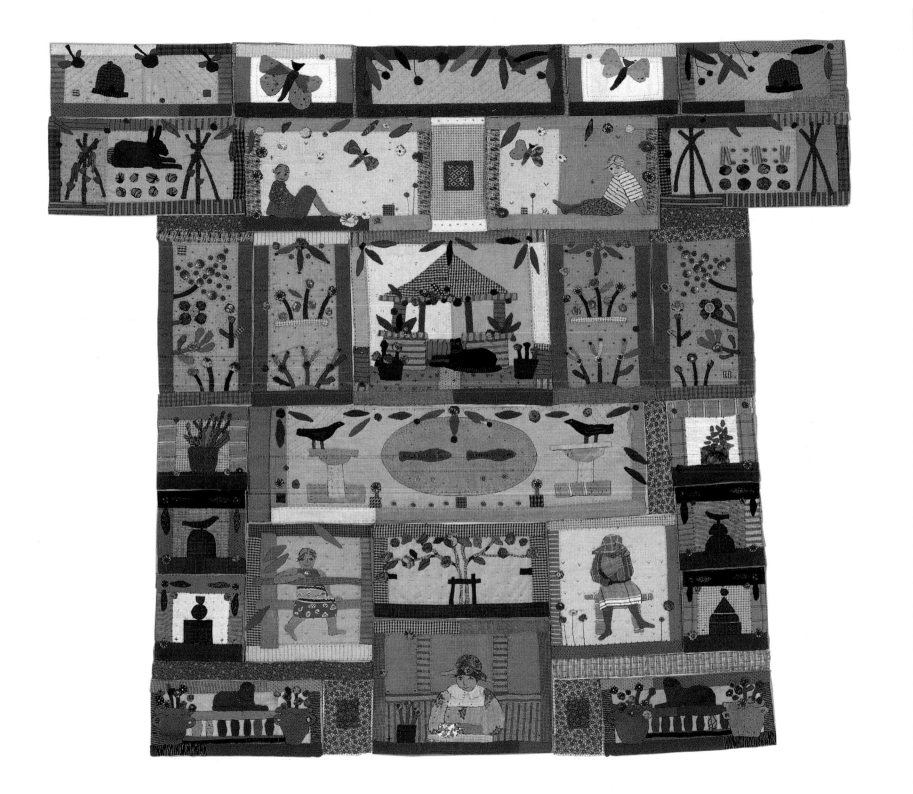

STITCH GLOSSARY

RUNNING STITCH

Push the needle up from the back of the work to the front, then insert the needle a short distance away. Take small stitches, working in a straight line. The gap between the stitches should be the same length as the stitch. If you look closely at my work you will notice that I vary both stitch and gap length.

BACK STITCH

Push the needle up from the back of the work, then take the needle down $^1/_8$ in/ 0.3cm away to the back. Bring the needle back up again to the front $^1/_8$ in/0.3cm from the end of the first stitch. Make the second stitch by inserting the needle in the end of the first stitch.

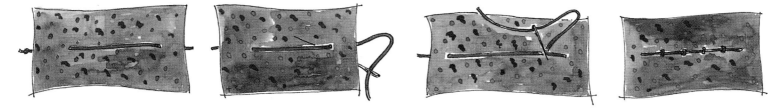

COUCHING

Lay a thread on the top of your work in the required position. Using a second thread, bring the needle up to the front of the work very close to the first thread. Stitch over the top of the laid thread. Bring the needle up a short distance from the first stitch and form the second stitch. For decorative effects try using different colored threads.

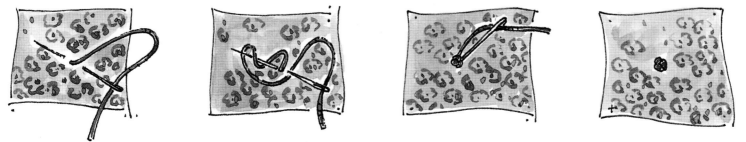

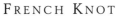

FRENCH KNOT

Bring the needle to the front of the work. Wrap the thread twice round the tip of the needle and pull tight. Insert the needle back in the fabric at a 90° angle. Holding the thread taut, push the needle through the fabric and the wrapped thread.

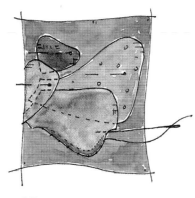

NEEDLE-TURNING

Fingerpress the seam allowance of your appliqué shape. Pin the shape in position. Use the tip of your needle to push small sections of the seam allowance under. Bring the needle up through the back of your work catching a thread of the folded edge of your appliqué shape. Then insert the needle back down to the back close to where you brought the needle up. Snip into the seam allowance for acute angles only.

OVERSTITCH

Work in a similar manner to running stitch. Here the stitches are worked side by side in a line rather than end to end.

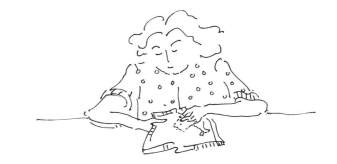

INDEX